DORLING KINDERSLEY 📖 EYEWITNESS BOOKS

IMPRESSIONISM

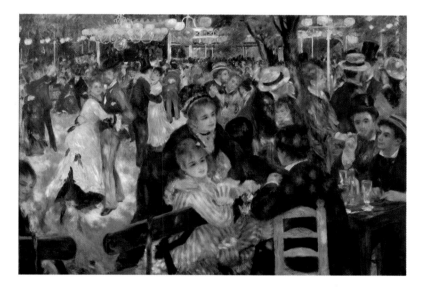

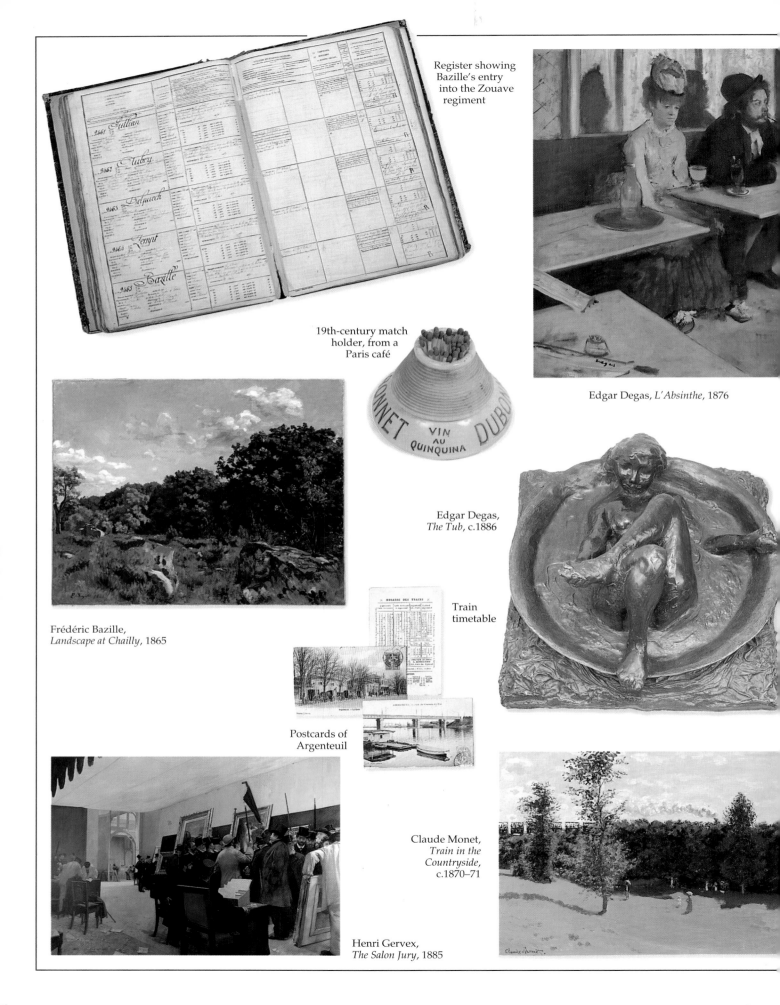

Register showing Bazille's entry into the Zouave regiment

19th-century match holder, from a Paris café

Edgar Degas, *L'Absinthe*, 1876

Frédéric Bazille, *Landscape at Chailly*, 1865

Edgar Degas, *The Tub*, c.1886

Train timetable

Postcards of Argenteuil

Claude Monet, *Train in the Countryside*, c.1870–71

Henri Gervex, *The Salon Jury*, 1885

DK EYEWITNESS BOOKS

IMPRESSIONISM

JUDE WELTON

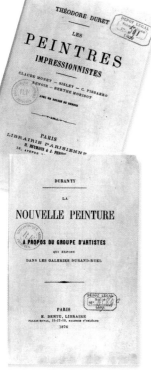

19th-century
snapshot camera

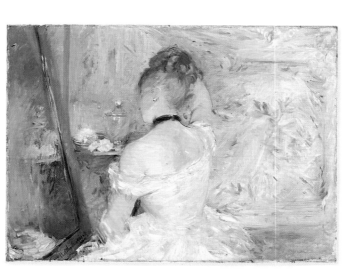

Berthe Morisot, *Lady at her Toilette*, c.1875

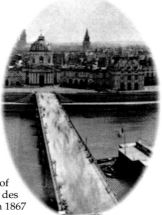

Photograph of
the Pont des
Arts in 1867

The first pamphlets dedicated
to Impressionist principles

A theater fan

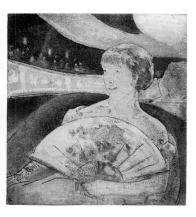

Mary Cassatt,
In the Opera Box, c.1880

Pissarro's letter sketch of a
painting sent to Durand-Ruel

DK

Dorling Kindersley
IN ASSOCIATION WITH
THE ART INSTITUTE OF CHICAGO

Etching and drypoint
tools with a copper plate

Dorling Kindersley

LONDON, NEW YORK, AUCKLAND, DELHI,
JOHANNESBURG, MUNICH, PARIS and SYDNEY

For a full catalog, visit

www.dk.com

To mum and dad

Editor Luisa Caruso
Art editor Liz Sephton
Assistant editor Louise Candlish
Assistant designer Simon Murrell
Senior editor Gwen Edmonds
Senior art editor Toni Kay
Managing editor Sean Moore
Managing art editor Tina Vaughan
US editor Laaren Brown
Picture researcher Julia Harris-Voss
DTP designer Doug Miller
Production controller Meryl Silbert

This Eyewitness ® Book has been conceived by
Dorling Kindersley Limited and Editions Gallimard

© 1993 Dorling Kindersley Limited
This paperback edition © 2000 Dorling Kindersley Limited
First American edition, 1993

Published in the United States by
Dorling Kindersley Publishing, Inc.
95 Madison Avenue
New York, NY 10016
2 4 6 8 10 9 7 5 3 1

Dorling Kindersley books are available at special discounts for bulk purchases for sales
promotions or premiums. Special editions, including personalized covers, excerpts of
existing guides, and corporate imprints can be created in large quantities for specific
needs. For more information, contact Special Markets Dept., Dorling Kindersley
Publishing, Inc., 95 Madison Ave., New York, NY 10016;
Fax: (800) 600-9098

Library of Congress Cataloging-in Publication Data
Welton, Jude.
Impressionism / written by Jude Welton.
p. cm. — (Eyewitness Books)
Includes index.
1. Impressionism (Art)—France. 2. Painting, French.
3. Painting, Modern—19th century—France. 4. Paris (France) in art.
5. Paris (France)—Social life and customs—19th century.
I. Title. II. Series.
ND547.5.I4W44 2000
759.4'09'034—dc20 92-54545
 CIP
ISBN 0-7894-6176-5 (pb) ISBN 0-7894-5583-8 (hc)

Color reproduction by Colourscan, Singapore
Printed in China by Toppan Printing Co. (Shenzhen) Ltd.

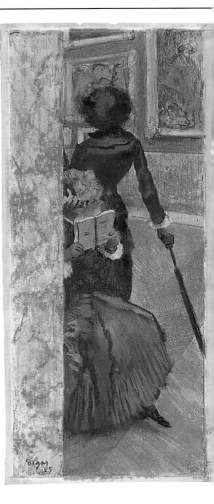

Edgar Degas, *Mary Cassatt
at the Louvre*, 1885

The Paris Opéra

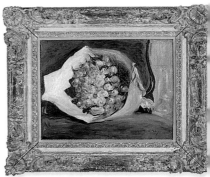

Auguste Renoir,
Bouquet in a Theater Box, c.1871

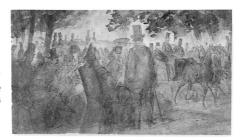

Constantin Guys'
sketch of the
Champs-Elysées

Photograph of the American art
collector, Bertha Palmer

Fashionable
veiled hat

Contents

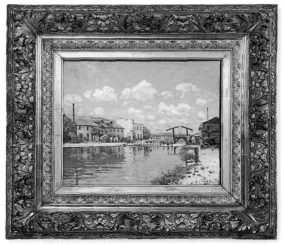

Alfred Sisley,
Saint-Martin Canal, 1872

What is Impressionism?

IMPRESSIONISM DEFIES EASY DEFINITION. Although it now refers to the most popular movement in Western art, it originated as a term of abuse – applied to an exhibition of works that appeared shockingly sketchy and unfinished. The artists who created these works were united in their rejection of the old, "tame" art encouraged by the official Salon (p. 18), but their artistic aims and styles varied. They did have two fundamental concerns: depicting modern life and painting in the open air. Yet neat "group definitions" fail even here. Alfred Sisley, for example, had little interest in anything but landscapes, while Edgar Degas ardently opposed painting outdoors. Despite their differences, Claude Monet, Berthe Morisot, Auguste Renoir, Camille Pissarro, Alfred Sisley, Gustave Caillebotte, Edgar Degas, and Mary Cassatt developed a new way of depicting the world around them, and, together with other artists, they displayed their work in the "Impressionist exhibitions" (p. 62) held between 1874 and 1886 in Paris.

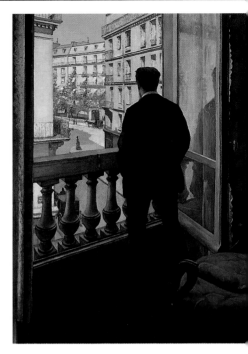

THE MAN AT THE WINDOW
Gustave Caillebotte; 1876; 45¾ x 32 in (116.2 x 80.9 cm)
A sophisticated Parisian observes city life outside his window. In its modernity, matter-of-factness, and its theme of observation, this image shows the central characteristics of Impressionism.

The making of modern Paris

Modern Paris was the catalyst, the birthplace, and the subject matter of much of Impressionist art. In the 1850s it was still a medieval city of narrow, winding streets with little sanitation or outdoor lighting. By the 1870s, the heyday of Impressionism, the old city had been razed to the ground and rebuilt as a modern metropolis of long boulevards lined with cafés, restaurants, and theaters.

THE EMPEROR
Commerce prospered under Emperor Napoleon III's authoritarian Second Empire. When he became Emperor in 1851, he set out to make Paris the showpiece of Europe.

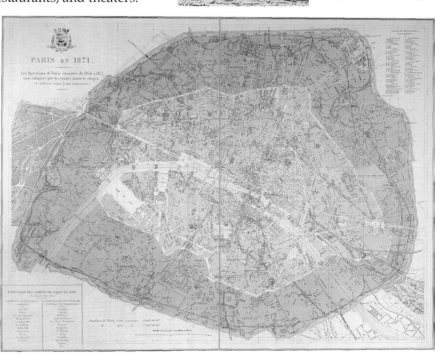

THE ARCHITECT
Napoleon's architect, Baron Haussmann, ruthlessly rebuilt Paris, displacing over 350,000 people. Evicted workers were forced to migrate to the outskirts of the city, while the affluent middle classes moved into Haussmann's elegant new buildings.

A NEW MAP OF PARIS
This map of Paris in 1871 shows how Haussmann's plans for the city created an efficient network of boulevards. During the rebuilding, he created 31 miles (50 kilometers) of new boulevards, laid out vast areas of parks and squares, built churches, and began construction of the Opéra and the Louvre Palace. In the two decades (1851–71) in which the Emperor was in power, the population of Paris doubled.

BOULEVARD HAUSSMANN
Named after its architect, this tree-lined boulevard, with its spacious pavements and elegantly balconied apartments, is typical of the Paris seen in Impressionist paintings.

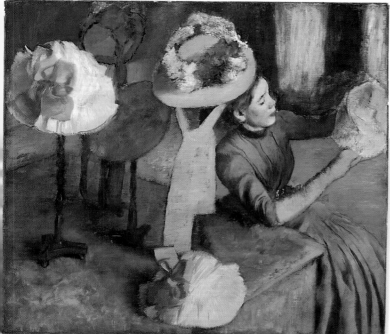

THE MILLINERY SHOP
Edgar Degas; 1879–84; 39½ x 43½ in (100 x 110.7 cm)
Unlike the work of his Impressionist colleagues, Degas' art was characterized by a passion for line, and his compositions were made in the studio – "A painting is an artificial work existing outside nature," he said. Although this painting is distanced from "pure" Impressionism by its draftsmanship and carefully worked surface, the modern Parisian theme, the off-center composition, and the apparently unposed milliner place it firmly at the core of Impressionist art.

Duret's pamphlet, "with a drawing by Renoir"

"The New Painting with regard to the ... artists who are exhibiting in the Durand-Ruel galleries"

EARLY WRITINGS
Edmond Duranty's essay of 1876, *La Nouvelle Peinture*, was the first publication about the principles of Impressionist art. Théodore Duret's pamphlet followed two years later.

PARISIANS AT PLAY
The leisure activities of their fellow Parisians were a central Impressionist theme. In 1869, Renoir and Monet painted side-by-side at the popular boating and bathing resort of La Grenouillère.

BATHERS AT LA GRENOUILLERE
Claude Monet; 1869; 28¾ x 36¼ in (73 x 92 cm)
The artist whose work most unequivocally represents the aims of Impressionism is Claude Monet. He was dedicated to painting in the open air, to capturing what he called "the most fugitive effects" of nature, and he used pure, bright colors based on what his eyes saw rather than on what the conventions of painting decreed. Abandoning traditional historical or religious themes, he also rejected the highly finished techniques of academic art. This is one of the earliest examples of the new style: Monet creates a vivid impression of the bustling activity at La Grenouillère and the glittering effect of sunlight on water.

Manet's painting of modern life

"MAKE US SEE AND UNDERSTAND, with brush or with pencil, how great and poetic we are in our cravats and our leather boots," wrote the poet Charles Baudelaire. Edouard Manet took up his friend's challenge in this remarkably innovative painting of fashionable Parisians gathered for a concert. It was hugely influential for the younger generation of artists who later became known as the Impressionists, anticipating their work in both subject and style. The modernity of the theme is matched by daringly sketchy brushwork that lacks the smooth "finish" expected in oil painting at that time, and by the unfocused, friezelike composition. Inspired by photography and the style of Japanese prints (pp. 28–29; 54–55), Manet cropped off figures at the edge of the canvas, so that the composition gives the impression of being a slice of life that continues beyond the frame. His revolutionary attitude toward art made Manet the acknowledged figurehead of the Impressionists, but he refused to exhibit with them, craving official recognition that only the Salon could offer.

EDOUARD MANET
(1832–1883)
Son of the chief of staff at the Ministry of Justice, Manet was the reluctant leader of avant-garde art, who drew inspiration from the art of the past. He met Edgar Degas – who etched the portrait above – in the Louvre.

CHARLES BAUDELAIRE
Edouard Manet; 1869; etching
During the winter of 1859–60, the poet Charles Baudelaire wrote a long essay, *Le Peintre de la Vie Moderne* – "The Painter of Modern Life." It not only inspired his friend Manet but encouraged the Impressionist artists to portray contemporary life.

THE CHAMPS-ELYSEES
Constantin Guys; 1855; 9½ x 16¼ in (24 x 41 cm); pen and ink on paper
Manet was an admirer of Constantin Guys, the artist-illustrator whose acutely observed images of Parisian society inspired Baudelaire's influential essay. Manet owned several of Guys's pen-and-ink washes: the jaunty, staccato rhythm created by the angled top hats and the simplifications of figures in rapid sketches like this are echoed in Manet's painting (right).

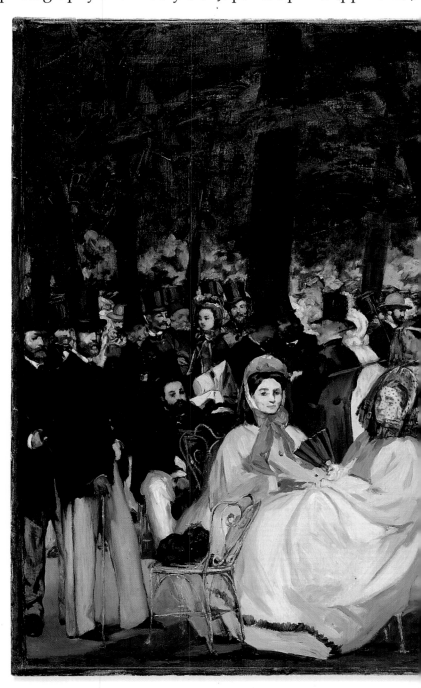

Music in the Tuileries

EDOUARD MANET *1862; 30 x 46½ in (76 x 118 cm)*

Manet presents himself (on the far left) and his sophisticated set: Baudelaire, the composer Jacques Offenbach, the painter Henri Fantin-Latour, and other members of Parisian high society are clearly identifiable. Abandoning the traditional pictorial device of leading the eye into the picture to a point of focus, Manet stretches his figures across the canvas in a flat band. Some critics saw this as a simple inability to compose a picture. But although Manet contrived to make the composition appear unplanned, it was carefully constructed in the studio from open-air studies made in the Tuileries.

Top hat: fashion symbol of the *flâneur*

FASHIONABLE HATS
Manet himself epitomized Baudelaire's concept of the modern artist as a *flâneur*, a dandy who observes life with cool detachment. The dandy's trademark was the top hat, which appears throughout the painting below. Baudelaire maintained that fashion was an aspect of modernity that should be portrayed in art.

Veiled hat, similar to that worn by Mme. Lejosne (below)

GREEN CANOPY
Broken only by a triangle of blue sky, a green canopy of leaves forms a dark band across the top of the canvas, emphasizing the pattern of light and dark created by the figures below.

UNFINISHED FIGURES
The painting of the figures shows Manet's bold new technique. Rather than carefully modeling his forms, he has used contrasting blocks of light and dark color. Some faces are detailed, but others are barely sketched in.

SPLASHES OF COLOR
Among the dominant black coats and top hats of the assembled dandies, the pale dresses and blue, red, and orange ribbons stand out as vivid patches of brightness.

The new metal chairs in the Tuileries form part of the painting's design

Student days

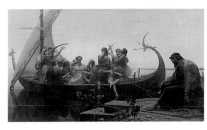

LOST ILLUSIONS
Charles Gleyre; 1843; 61¼ x 93¾ in (156 x 238 cm)
Gleyre's immaculately executed, mythical scene won a medal at the Salon in 1843. In the same year, he opened his teaching studio where he taught for 21 years.

MOST OF THE FUTURE IMPRESSIONISTS met as students in the teaching studios of Paris in the late 1850s and early 1860s. They had arrived via a variety of routes. The oldest of the group, Camille Pissarro, had trained in the West Indies before he met Claude Monet and Paul Cézanne at the Académie Suisse in Paris. Unlike other studios, which provided tuition, this was run by an ex-model as a convenient place to paint and draw. Monet later bowed to family pressure and joined the studio of the respected teacher Charles Gleyre, whose art was rooted in the academic tradition. Here, he established close friendships with three fellow students: Auguste Renoir, who had painted porcelain before training as an artist; the Parisian-born Englishman Alfred Sisley, who had rejected his family business for painting; and Frédéric Bazille, a well-to-do medical student with a passion for art.

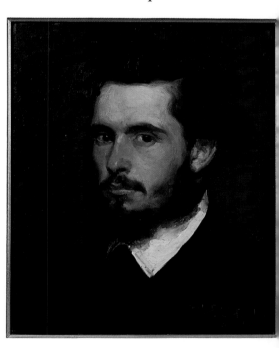

CLAUDE MONET
Charles Emile-Auguste Carolus-Duran; 1867; 18 x 15 in (46 x 38 cm)
This portrait of Monet was made three years after Gleyre's studio had closed. Monet later created a negative impression of his teacher, noting in 1900 that Gleyre had criticized the unidealized ugliness of a nude he had drawn. Yet Gleyre supported originality in his pupils and encouraged them to work outdoors.

ALFRED SISLEY
Auguste Renoir; c.1875–76; 26¼ x 21½ in (66.4 x 54.2 cm)
Sisley described Gleyre's low-key approach: "the boss ... comes in twice a week and inspects the work of each student, correcting his drawing or painting." Sisley's first close friend at the studio was Renoir, who painted this portrait.

AUGUSTE RENOIR
Frédéric Bazille; 1867; 24½ x 20 in (62 x 51 cm)
Renoir recalled that Gleyre left his pupils "to their own devices," but one incident marks Renoir's own response to academic art. Glancing at his attempts to copy a model, the master remarked, "No doubt it is to amuse yourself that you are dabbling in paint?" "Yes, of course," replied Renoir. "If it didn't amuse me, I certainly wouldn't do it." Bazille's portrait of his friend captures Renoir's edgy, nervous temperament.

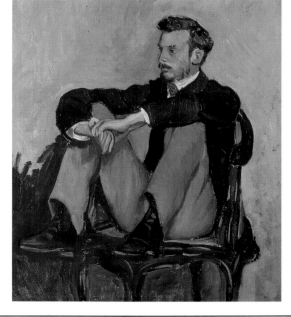

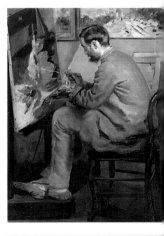

FREDERIC BAZILLE
Auguste Renoir; 1867; 41¼ x 29 in (105 x 73.5 cm)
Gleyre's students were a close group. Renoir's portrait of Bazille was painted, like Bazille's portrait of him, in 1867. The wealthy artist was supporting Renoir by allowing him to live in his apartment. A penniless Monet joined them, too. When Bazille took over a studio and home in the Batignolles (p. 16), Renoir moved with him. Sisley lived in the same building.

Under Manet's influence

In the early 1860s, at a time when Monet, Renoir, Sisley, and Bazille all met at Gleyre's studio, another significant event occurred in the history of Impressionism. It was then that Edgar Degas met Edouard Manet. Degas had trained at the Ecole des Beaux-Arts, France's official art school, before traveling to Italy, where he studied the masters of antiquity and the Renaissance. But under Manet's influence, he turned away from his classical subject matter to concentrate on modern-life themes. Manet also had a decisive influence on the style of another future Impressionist, Berthe Morisot, his model and protégée.

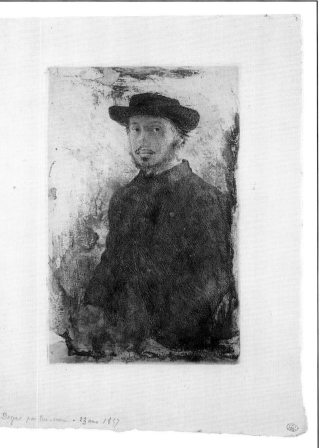

SELF-PORTRAIT
Edgar Degas; 1857;
9 x 5¾ in (23 x 14.3 cm); etching
Executed in Italy in 1857, this etching shows the characteristically sullen young Degas in artist's dress, wearing soft hat and cravat. Clearly inspired by the etched self-portraits of Rembrandt, it reveals Degas' manipulation of the 17th-century master's techniques.

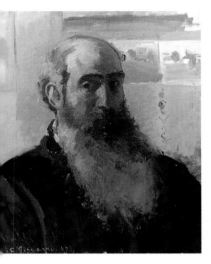

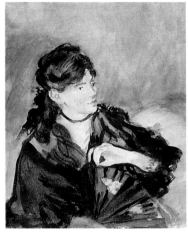

SELF-PORTRAIT
Camille Pissarro; 1873; 22 x 18½ in (56 x 46.7 cm)
Pissarro had a varied background. He studied with Beaux-Arts teachers, as well as attending informal studios. Like Morisot, he also received guidance from the great landscape artist Camille Corot (p. 13).

PORTRAIT OF BERTHE MORISOT
Edouard Manet; 1874; 8 x 6½ in (20.9 x 16.8 cm); watercolor
Morisot (left) was given private lessons by an academic painter, Joseph Guichard, who feared such ability in a woman could be "catastrophic ... in [her] high bourgeois milieu." She copied works by Old Masters at the Louvre and received informal tuition from Camille Corot, but it was Manet who influenced her most.

SKETCHING COMPETITIONS
Being female, Morisot was not permitted to enter the Ecole des Beaux-Arts. But Renoir, Degas, and Pissarro all attended classes there. At that time, training focused on drawing, and was geared toward annual competitions (left).

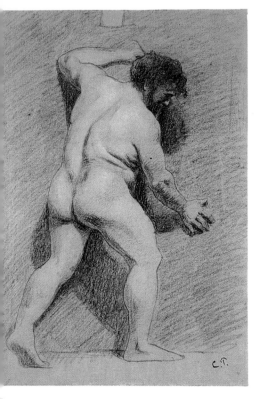

STUDY OF A MALE NUDE
Camille Pissarro; c.1855–60; 18½ x 11½ in
(46.8 x 29 cm); charcoal and chalk on paper
Apart from Degas, Pissarro was the most prolific draftsman of the Impressionists. This powerful charcoal study of a heavily built life model dates from shortly after his arrival in France in 1855, and was executed either at the Académie Suisse or the Ecole des Beaux-Arts.

VENUS, AFTER MANTEGNA
Edgar Degas; c.1855; 11½ x 8 in (29 x 20 cm); pencil on paper
Also made in about 1855, this copy, after a figure by the 15th-century painter Andrea Mantegna, illustrates Degas' admiration for Renaissance art. Precisely drawn contours contain the delicately modeled figure. It was at this time that Degas met the great master J.-A.-D. Ingres, who advised him "Draw lines, young man, many lines."

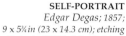

Painting outdoors

PORTABLE EQUIPMENT
Portable easels and other equipment became available for landscape painters. Catalogs such as this, from Lefranc & Company, offered a wide range, including an outdoor painting kit (above).

Pᴀɪɴᴛɪɴɢ ɪɴ ᴛʜᴇ ᴏᴘᴇɴ ᴀɪʀ (*en plein air*) was central to Impressionism, with artists leaving the confines of their studios to paint directly and spontaneously from nature. However, it was not a new activity. Throughout the 19th century, it had been common practice for landscape painters to make rapid oil sketches in the open air, though these were usually considered studies for a finished painting, to be composed later in the studio. Since the 1840s, the villages of Barbizon and Marlotte in the forest of Fontainebleau had become associated with *plein-air* painting.

OFF TO PAINT
This powerful little sketch by Cézanne shows Pissarro on his way to paint.

Charles François Daubigny, one of the Barbizon School, was among the first to consider his paintings from nature finished enough to exhibit. Significantly, he was criticized for "being satisfied with an impression." Of the group from Gleyre's studio, Monet had been converted to painting outdoors by Eugène Boudin and Johan-Barthold Jongkind on the Normandy coast. And from 1863, he led painting expeditions to Fontainebleau, where he, Renoir, Bazille, and Sisley developed the language of Impressionist art.

FOREST ATTRACTIONS
The forest of Fontainebleau – just one hour from Paris by the newly built railroad – offered a multitude of attractions for tourists and artists alike. By the 1860s, open-air painting had become something of a craze.

LANDSCAPE AT CHAILLY
Frédéric Bazille; 1865;
32 x 39½ in (81 x 100.3 cm)
In the summer of 1865, Bazille and his friend Monet were based at Chailly-en-Brère in the forest of Fontainebleau. Chailly was near the village of Barbizon, where the older generation of landscape painters, led by Théodore Rousseau, had been working for several decades. Dedicated to the idea of "truth to nature," they had created a new type of landscape – unidealized and devoid of carefully arranged classical ruins, or historical incidents. Following their lead, Bazille painted directly in front of his subject. The broad, individualized strokes of paint and the concern with the effects of light on the foliage look forward to Impressionism. But it is not yet an Impressionist landscape: its relatively dark palette and the absence of any sign of human beings make it closer in spirit to the art of the Barbizon painters.

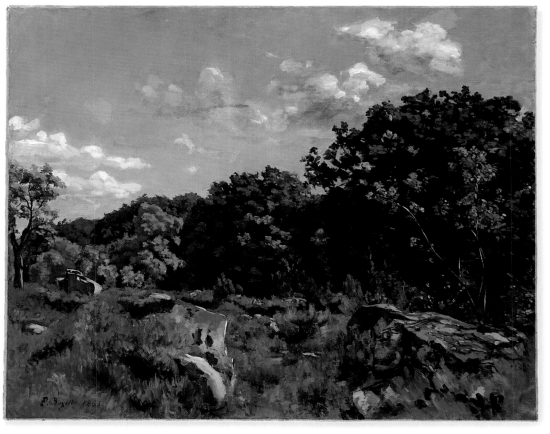

VIEW OF GENOA
Camille Corot; 1834;
11½ x 16½ in (29.5 x 41.7 cm)
Though Corot's *plein-air* landscapes such as this were executed as studies for studio works, even his finished paintings retain a sense of immediacy and freshness. He painted this early work on paper (he later mounted it on canvas), using broad, simplified shapes and replacing the convention of artificially dark shadows with a high-toned luminosity. His advice to "submit to the first impression" could be seen as a central tenet of Impressionism – yet Corot disapproved of "that gang," as he called them.

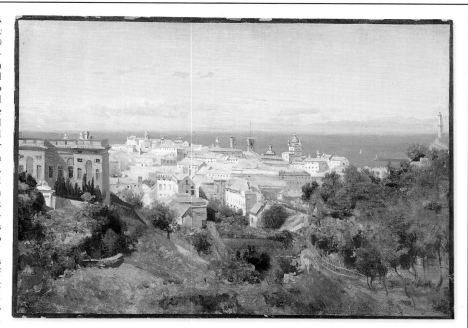

CAMILLE COROT
(1796–1875)
Seen here beneath his painting umbrella, Corot was one of the greatest landscape artists of the 19th century and a hero to most of the Impressionists. He taught both Morisot and Pissarro.

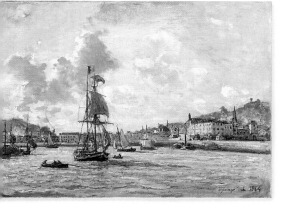

ENTRANCE OF THE PORT OF HONFLEUR
Johan-Barthold Jongkind; 1864; 16½ x 22¼ in (42.2 x 56.2 cm)
Jongkind had a powerful influence on the development of Impressionism. "To him," Monet said, "I owe the final education of my eye." The atmospheric effects and thickly applied (impasto) brushstrokes of marine views such as this create an impressive sense of spontaneity. Yet Jongkind painted in his Paris studio, from preparatory sketches.

Collapsible tubes of paint

STORING PAINT
The invention of metal tubes in the 1840s allowed long-term storage of oil paints, making extended outdoor oil-painting trips much more feasible. Until then, oil paints were stored in little pouches made from pigs' bladders (left). The painter pierced the skin with a tack, squeezed out the paint, and used the tack as a plug. However, the paint hardened rapidly with exposure to air.

DAUBIGNY'S STUDIO BOAT
Determined to confront nature in the raw, Daubigny built lean-to huts to shelter himself from the elements as he painted in the open air. In 1857, he even built himself a studio boat (*botin*) on which he could live and work. In this etching, he depicts himself painting in his *botin*.

Modern replica of Monet's studio boat

MONET'S FLOATING STUDIO
Following Daubigny's example, Monet had a floating studio built when he lived by the Seine River at Argenteuil in the 1870s. But while Daubigny used his *botin* to travel to remote stretches of the river, staying on board for long periods, Monet rarely traveled far and often moored to paint in the midst of local yachts.

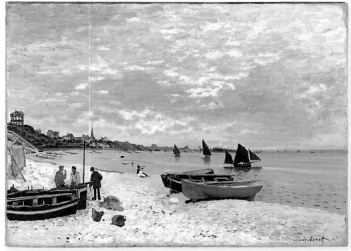

THE BEACH AT SAINTE-ADRESSE
Claude Monet; 1867; 30 x 40½ in (75.8 x 102.5 cm)
This Normandy beach scene, painted on the spot near Monet's family home, owes a debt to Boudin and Jongkind. Its sketchy, broken brushwork, bright colors, and modern subject matter anticipate Monet's mature Impressionist style of the 1870s. Indeed, it was shown at the second Impressionist exhibition.

Monet and the Seine

CLAUDE MONET
(1840–1926)
The son of a well-off businessman, Monet became a driving force in Impressionism.

THIS IS ONE of the earliest recognizably "Impressionist" landscapes. Painted in the open air, in a few sittings at the most, with the broad, bright, slablike patches of color characteristic of Monet's Impressionist style, it has a sketchy boldness that is astonishing. The woman sitting by the river is Monet's future wife, Camille, but the picture is in no way a portrait of her: Monet's interest lies not in details, but in capturing the effect of the whole scene as it would be perceived in a fleeting glance. The painting was displayed in the second Impressionist exhibition of 1876, eight years after it was executed.

A LATER SKETCH OF BENNECOURT
On the right-hand sketch, Monet has noted the time of day – "noon–1p.m." – reflecting his interest in changing light conditions throughout the day.

Chrome yellow

Lead white

ARTIST'S PALETTE
Monet's palette probably includes chrome yellow, lead white, cobalt blue, emerald green, and viridian green.

Cobalt blue

Viridian green

Emerald green

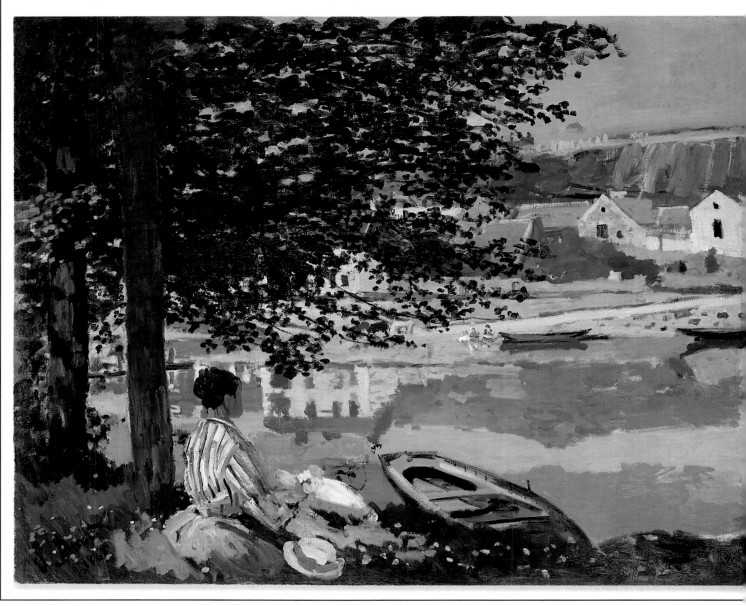

REFLECTIONS FROM THE SHORE

Throughout his painting career, one of Monet's main concerns was with capturing the fleeting effects of light on water. The impermanent reflections on the river's surface appear as substantial as any of the tangible elements of the painting. This detail shows the artist's varying technique: a few squiggles from a well-loaded fine brush are used for the people, while wider, square-ended brushes create scrubbed areas and distinct, slablike strokes.

A few individual strokes depict the boat and its reflection

Dots and dashes of green show grassy patches

Facial features are distinguishable beneath the roof reflections

SKY ON WATER

Concerned as much with the visual structure of the picture as with capturing natural effects, Monet added this patch of bright blue reflection after painting the dark grass – deliberately creating a diagonal link with the sky at the top right.

ALTERED IMAGE

Monet clearly altered the composition as he worked, most drastically changing the area above the woman's lap. The existing figure replaced a frontal view of a woman; the original pinkish flesh-tones of her face show through the cream and brown overpainting.

Long, rectangular strokes describe the trunk's mottled surface but not its rounded form

On the Seine at Bennecourt

CLAUDE MONET

1868; 32 x 39½ in (81.5 x 100.7 cm)

Painted in 1868, this image of Camille on a riverbank at Bennecourt was executed during a time of radical experimentation for Monet, as he rejected the highly finished surfaces and lofty themes of academic art. A rare surviving example of work from that period, it shows him creating a new visual language of bright, rapidly applied color to capture open-air effects.

HAT AND FLOWERS

Monet accentuates the informality of the scene by painting the yellow hat casually discarded on the flower-dotted grass. Broad brushstrokes depict the hat and its bright blue ribbon, while the "flowers" themselves are simply specks of yellow and white, dabbed onto the scrubbed green paint that indicates the grassy bank.

The Batignolles group

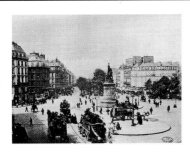

THE PLACE DE CLICHY
Torn down and rebuilt by Baron Haussmann (p. 6), the Batignolles quarter epitomized the new Paris that would be associated with Impressionism. At its center was the spacious Place de Clichy.

If IMPRESSIONISM HAD A BIRTHPLACE, it was the Batignolles district of Paris. Many avant-garde artists and writers lived there, and from the late 1860s, Manet was at the center of evening gatherings in the local Café Guerbois, where animated discussions of modern art took place. Along with a number of critics who supported Manet's controversial painting, younger artists such as Fantin-Latour, Degas, and Bazille (a family friend of Manet's) became Café Guerbois regulars. Bazille brought along friends he had met at Gleyre's studio – Monet, Renoir, and Sisley. Pissarro and Cézanne also came occasionally. But in July 1870, violent forces scattered the Batignolles group, as France embarked on a disastrous war with Prussia. Manet and Degas joined the National Guard, while Monet, Sisley and Pissarro fled to England. Renoir was posted far from the fighting. But Bazille was less fortunate: he was killed in action at the age of 29.

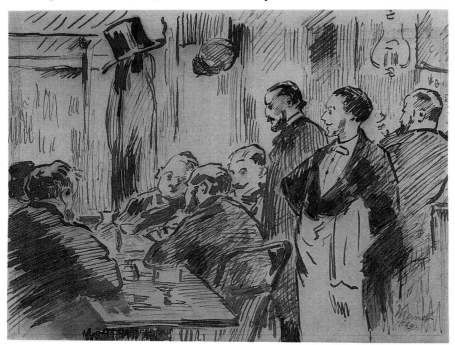

THE CAFE GUERBOIS
Edouard Manet; 1869; 11¾ x 15½ in (29.5 x 39.5 cm); pen and ink on paper
In the heart of the Batignolles quarter, near the Place de Clichy, the Café Guerbois was the site of many discussions on art. In this vivid pen-and-ink drawing, thought to be of the Guerbois, Manet has captured the atmosphere of an artists' café. Most evenings, and particularly on Thursday, the group of Manet's friends and admirers included the novelist and journalist Emile Zola and progressive critics such as Zacharie Astruc, Edmond Duranty, and Théodore Duret. Manet was "overflowing with vivacity," but he did not like to be contradicted. After one heated discussion at the café, he even challenged Duranty to a duel. Duranty was wounded, but that evening they were friends again, and the café regulars composed a song in their honor.

EMILE ZOLA
Edouard Manet; 1867–68;
57¾ x 45 in (146.5 x 114 cm)
A boyhood friend of Cézanne's, Zola used his column in the daily newspaper *L'Evénement* to champion Manet and the "naturalists," as he called the future Impressionists. In 1868, he noted that "they form a group that grows daily. They are at the head of the [modern] movement in art."

A STUDIO IN THE BATIGNOLLES QUARTER
Henri Fantin-Latour; 1870; 80¼ x 107¾ in (204 x 273.5 cm)
Exhibited at the Salon of 1870, Fantin-Latour's formal homage to his friend Manet echoes his earlier tribute to Eugène Delacroix. The dapper Manet sits at his easel, painting a portrait of Astruc. Standing (left to right) are Otto Scholderer (a German Realist painter), Renoir, Zola, Edmond Maître (a musician friend of Bazille's), Bazille, and Monet.

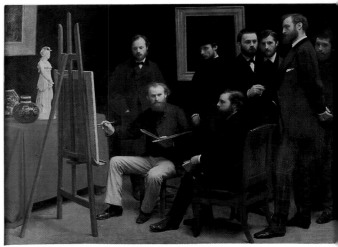

ZOLA'S DAMNING NOVEL
Zola's relationship with the Impressionists came to a bitter end in 1886 with his novel *L'Oeuvre*. Its artist-hero – a mixture of Manet and Cézanne – dreams of greatness but finds only failure.

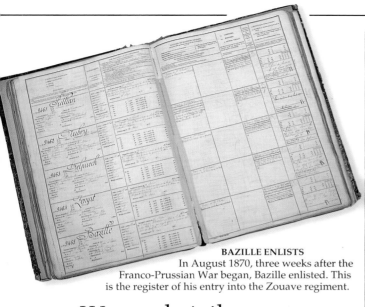

BAZILLE ENLISTS
In August 1870, three weeks after the Franco-Prussian War began, Bazille enlisted. This is the register of his entry into the Zouave regiment.

War and civil war

For the Impressionists, the greatest casualty of the war was Bazille. But there were other losses: Sisley's family business was ruined, and Pissarro returned to France to find that all but 40 of his 1,500 works had been destroyed when enemy troops requisitioned his house. Soon after France's defeat by the Prussians, civil war raged in the streets of Paris.

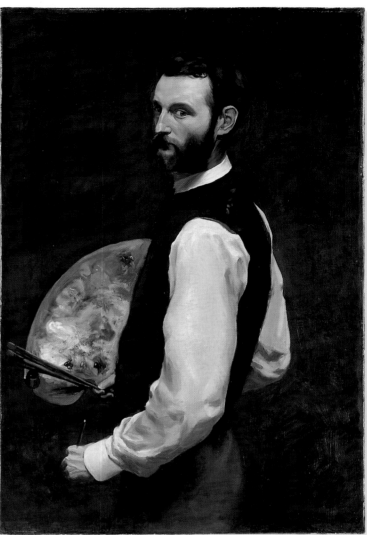

SELF-PORTRAIT
Frédéric Bazille; c.1865; 39 x 28¼ in (99 x 71.8 cm)
Five years after Bazille painted this stunning self-portrait, he was shot dead by a Prussian sniper. The gifted, generous young artist was deeply mourned by his friends.

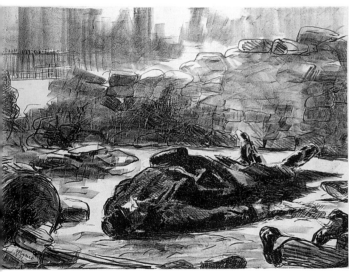

CIVIL WAR
Édouard Manet; c.1871;
5½ x 20 in (39.5 x 50.5 cm); lithograph
In March 1871, a radical, citizen-led regime, known as the Commune, set itself up against the French government at Versailles. The streets of Paris became a battleground, and more than 20,000 died in the intensely bloody civil war. Manet was in Paris for the last days of the Commune and witnessed this scene. Composed sometime after the event, the image of a dead Communard lying in the rain evokes the futility of war.

AT THE BARRICADES
Communards set up barricades to keep out government forces. But when the Versailles troops entered Paris in May 1871, thousands were slaughtered, even if they showed the white flag of surrender, as Manet's fallen soldier has done.

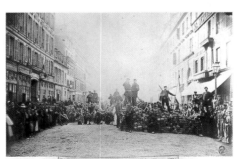

Barricade de la rue de Flandre, salle de la Marseillaise (18 mars 1871)

The Communard's medal: "*Le triangle de la Commune*"

18 MARS 1871

COMMUNE RIFLE
Designed by Alphonse Chassepot in 1866, the Chassepot rifle was used extensively at the time of the Franco-Prussian War and the Paris Commune. A bayonet (left) was often attached to the rifle.

Rebelling against the Salon

THE IMPRESSIONISTS BEGAN THEIR CAREERS at a time when being a successful artist meant achieving official success at the Salon, France's annual artistic showcase. The Salon encouraged, exhibited, and rewarded immaculately finished, conventional paintings, often on historical, religious, and mythological subjects. There were exceptions, but the future Impressionists – with their sketchy technique, their concentration on modern landscapes, and apparently arbitrary views of contemporary Parisian life – were repeatedly rejected by the Salon jury. In 1874, they finally made a bid for independent recognition by boycotting the Salon and mounting a privately organized show of their own. From April to May, 30 members of the newly formed *Société Anonyme des Artistes Peintres, Graveurs* exhibited in what became known as the first "Impressionist exhibition."

SALON DES REFUSES
When thousands of works were rejected by the Salon jury of 1863, there was an outcry. The Emperor decreed that all the rejected works of art should be shown at an alternative Salon – the Salon of the Rejected. This one-time show exposed the gap between official and new, more modern art.

THE SALON JURY
Henri Gervex; 1885; 117¾ x 165 in (299 x 419 cm)
The Salon had begun in the 17th century as an exhibition of works by members of the French Royal Academy. After the French Revolution, the exhibition was open to all artists, but works were selected by a jury. By the Impressionists' day, artists were allowed to sit on the jury – but only those artists who had already won a Salon medal. Not surprisingly, there was a self-perpetuating strain of conservatism among the selectors. This painting shows the Salon jury in 1885, voting with their umbrellas and canes for a provocative, but timeless and safely passive nude.

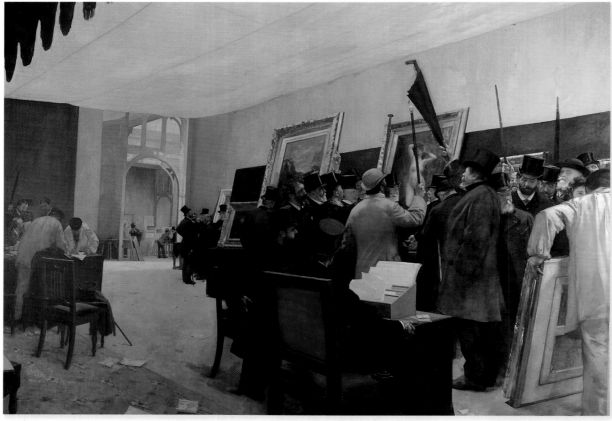

Scandal at the Salon

Manet's modern adaptations of 16th-century masterpieces caused uproar; the female nude in *Déjeuner sur l'Herbe* shocked the Salon des Refusés, and *Olympia* (left) scandalized the Salon of 1865.

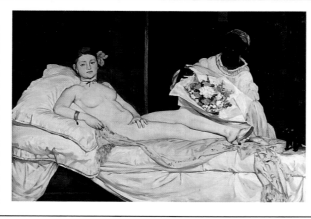

OLYMPIA
Edouard Manet; 1863; 51½ x 74¾ in (130.5 x 190 cm)
"Abuses rain on me like hail," wrote Manet when *Olympia* was exhibited. Today, it may appear no more shocking than the nude in Gervex's painting. To viewers of the time, the image of a modern prostitute shamelessly returning their gaze defied the conventions enshrined by the Salon.

MOCKING REVIEWS
It was standard for Salon reviews to mock exhibits. Cartoonists focused on *Olympia*'s gorillalike "ugliness" – lampooned here – and on Manet's bold contrasts between light and shade.

FIRST CATALOG
The *Société Anonyme* consisted of many artists as well as those now known as the Impressionists. Other exhibitors included Monet's old mentor, Eugène Boudin. Even with established names, the show was a critical and financial failure.

NADAR'S STUDIO
The first show was held in Paris, in the vacated studios of the celebrated photographer Nadar. He knew the group from the Café Guerbois (p. 24).

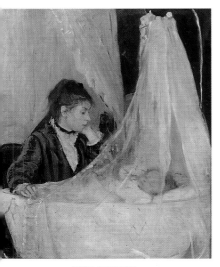

THE CRADLE
Berthe Morisot; 1872; 22 x 18 in (56 x 46 cm)
Morisot was the only female artist in the first exhibition. Her works included this broadly handled yet delicate view of her sister, Edma, watching over her baby daughter.

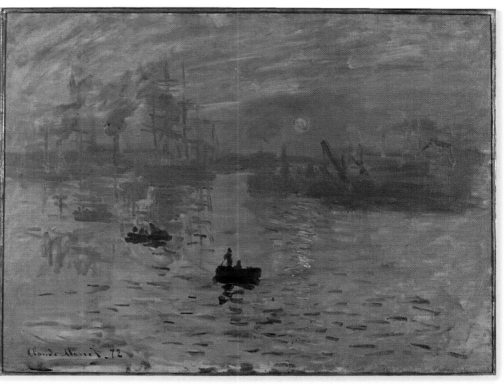

IMPRESSION, SUNRISE
Claude Monet; 1872; 19 x 24¾ in (48 x 63 cm)
Monet's choice of title for this sketchy view of Le Havre inadvertently led to the coining of the term Impressionism. "Impression," Louis Leroy wrote in the satirical journal *Le Charivari*. "Wallpaper in its embryonic state is more finished...." The label was soon adopted by others; within a year it had become an accepted term in the art world.

Impressionist exhibitions

By the 1860s, the Salon's stranglehold on the art world was loosening: Manet showed his paintings in his own pavilion at the 1867 World's Fair in Paris. In 1874, friends from the Café Guerbois held the first of eight shows. They chose not to give themselves a name that would imply a group style, but they were soon given one. Seizing on the title of Monet's *Impression, Sunrise* (above), the critic Louis Leroy called his scathing review of their show "Exhibition of the Impressionists."

CARTOON CRITICISM
One of many such attacks, this cartoon shows Impressionist works being used to scare an enemy.

TWILIGHT, WITH HAYSTACKS
Camille Pissarro; 1879; 4 x 7 in (10.3 x 18 cm); etching and aquatint
The Impressionists showed more than paintings in their exhibitions. For example, in the fifth show of 1880, Pissarro included several states of this superbly luminous print. It was printed in various colors – black, blue, brown, and red – as in this version printed by Degas. The colors reflected the way light changed through the day.

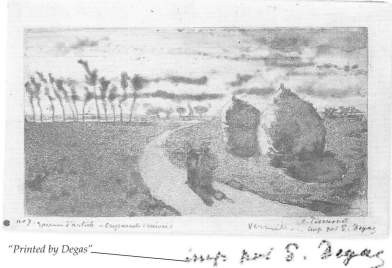

"Printed by Degas"

A revolution in color

IN THEIR USE OF COLOR, the Impressionists made their most significant break with academic tradition. Since their student days, they had admired the expressive color in works by the Romantic master Eugène Delacroix (1798–1863). But working in the open air had focused their interest on the fleeting light effects and colors of nature, which could only be captured in a more shorthand technique than the laborious process of academic art; the Impressionists used a limited range of bold colors to re-create the world as they saw it. Their observation that the colors of objects were not "fixed," but were modified by their surroundings, was confirmed by scientific findings. In the mid-19th century, Eugène Chevreul had shown how powerful optical effects could be obtained by placing colors next to each other.

THE COLORS OF THE SPECTRUM
In 1666, Sir Isaac Newton showed that white light could be sp into many colors – the spectrum or rainbow – by a prism. He identified the colors of the spectrum as red, orange, yellow, green, blue indigo, and violet. It became clea that there were three so-called primary colors – red, blue, and yellow – from which all the other colors could be mixed. By the 19th century, scientists understood that the human eye was sensitive to these three colors, and began to explore precisely how colors were perceived by the eye.

CHEVREUL'S COLOR CIRCLE
Chevreul's "law of simultaneous contrast" – which states that when two colors are placed next to each other, the differences between them appear at their greatest – formed the theoretical basis of Impressionist color. Chevreul designed this circle to indicate the precise relationships between colors: those on the blue side are termed "cool" and appear to recede; those on the red side are "warm" and seem to advance.

COMPLEMENTARY PAIRS
The basic complementary pairs of color are related to the primaries: each primary has a complementary created by mixing th other two. The eye perceives color as surrounded by its complementary, and neighboring complementaries create a vibrant effect as in Monet's painting (right)

Complementary colors are on opposite sides of the color circle

Chevreul's law of contrast

Chevreul first published his influential book, *On the Law of Simultaneous Contrast of Colors*, in 1839. It describes how neighboring colors modify each other, the most intense effects occurring when complementaries (above right) are contrasted. Chevreul even advocated using colored frames to heighten the colors in a painting, an idea favored by the Impressionist artists, but not by their dealers or buyers.

DELACROIX'S PALETTE
By mixing his colors with white, as he has done here, Delacroix increased the overall brightness of his paintings. His revolutionary use of color inspired the Impressionist artists. Like the Impressionists, he used color to indicate shadows, rather than adding black.

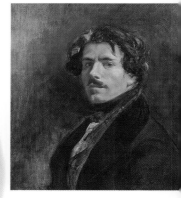

SELF-PORTRAIT
Eugène Delacroix; c.1837; 25½ x 21½ in (65 x 54.5 cm)
The supreme colorist of his day, and the Impressionists' idol, Eugène Delacroix knew of Chevreul's work. He made stunning use of complementary contrasts and banned "earth colors" – iron oxide pigments of dull reds, yellows, and browns – from his palette.

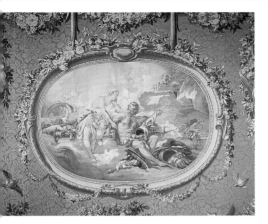

FROM TAPESTRY TO PAINTING

A distinguished chemist, Chevreul was the director of dyeing at the Gobelins tapestry factory in Paris. Investigating why some colors in tapestries such as this looked duller than others, he discovered that a color looked more or less bright depending on the colors surrounding it. The Impressionists exploited the effects of "simultaneous contrast" in the coloring of many of their works.

COLOR MERCHANTS

The Impressionist use of bright color was partly made possible by the rapid development of paint technology in the 19th century. A wider range of pigments became available, ready ground and in easily portable tubes (p. 13). These were sold by color merchants such as this one, pictured in about 1900.

REGATTA AT ARGENTEUIL

*Claude Monet; 1872;
19 x 29½ in (48 x 75 cm)*
In this rapidly executed river scene, Monet has made powerful use of the "law of simultaneous contrast" to reflect the scintillating effects of light on water. The most intense contrasts are between the complementary pairs red-green and blue-orange. Monet has also used subtle contrasts, such as the red-orange of the boathouses.

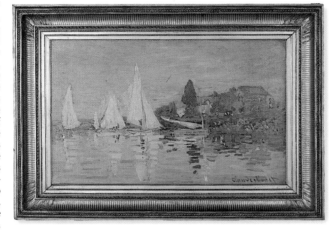

SLABS OF COLOR

To capture the ever-changing light effects they observed in nature, the Impressionists adopted a shorthand technique; applying paint in individual, contrasting slabs of bright color, as Monet has done here to indicate reflections.

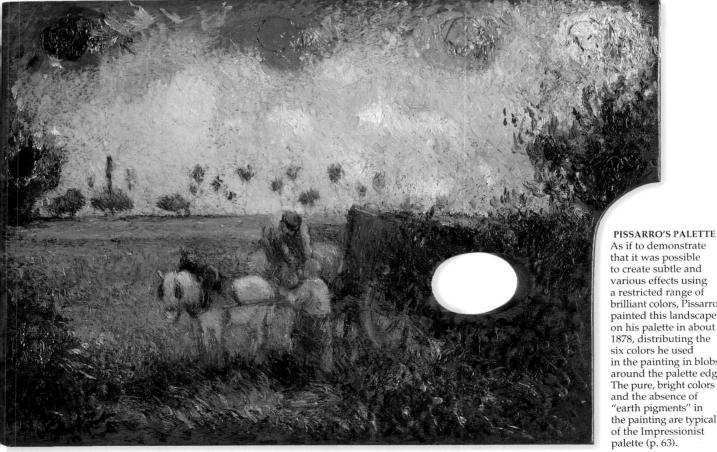

PISSARRO'S PALETTE

As if to demonstrate that it was possible to create subtle and various effects using a restricted range of brilliant colors, Pissarro painted this landscape on his palette in about 1878, distributing the six colors he used in the painting in blobs around the palette edge. The pure, bright colors and the absence of "earth pigments" in the painting are typical of the Impressionist palette (p. 63).

The Impressionist palette

DECORATIVE INSPIRATION
Since his early training as a porcelain painter, Renoir had loved 18th-century decorative art, particularly works by François Boucher. This exquisite porcelain by Boucher shows the vivid effect of pure, clear colors on a white base, which inspired the young Renoir.

RENOIR WAS ONE OF THE MOST brilliant colorists in the Impressionist group. As a teenager, he had apprenticed to be a porcelain painter, and in the ceramics workshop he learned how to use the most pure and vibrant colors to achieve his effects. Just as a white porcelain base accentuated the clarity and brilliance of painted color, so Renoir knew that a canvas primed (p. 63) with white or cream made the pigments appear lighter and brighter. Like his fellow Impressionists, he rejected painting on traditional dark grounds in favor of very pale or white grounds. The coloring of *Two Sisters* is based on Renoir's visual sense and intuition rather than on theory. Yet it is almost a textbook example of how the Impressionist artists used Chevreul's "law of simultaneous contrast" (pp. 20–21) in their painting techniques.

ARTIST'S PALETTE
Like the other Impressionists, Renoir generally restricted his palette to a limited number of pure, rather than mixed, colors. Analysis at the Art Institute of Chicago has identified the following pigments: lead white, vermilion, emerald green, cobalt blue, Naples yellow, crimson lake, and ultramarine blue – and the use of lead white priming.

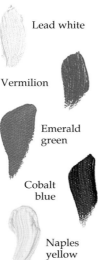

Lead white

Vermilion

Emerald green

Cobalt blue

Naples yellow

Two Sisters
AUGUSTE RENOIR
1881; 39½ x 32 in (100.5 x 81 cm)

This charming, almost life-size picture was probably painted at Chatou, a riverside resort outside Paris, where Renoir spent the spring of 1881 "struggling with trees ... women and children." The artist has used the terrace balustrade to divide the picture space into foreground and background. While the most intense colors have been used to depict the foreground figures, the colors are diluted in the distance. To avoid overmixing and so retain the purity of his colors, Renoir mixed his paints on the canvas rather than on the palette, and applied them wet-in-wet – adding colors next to or into another, before the first is dry.

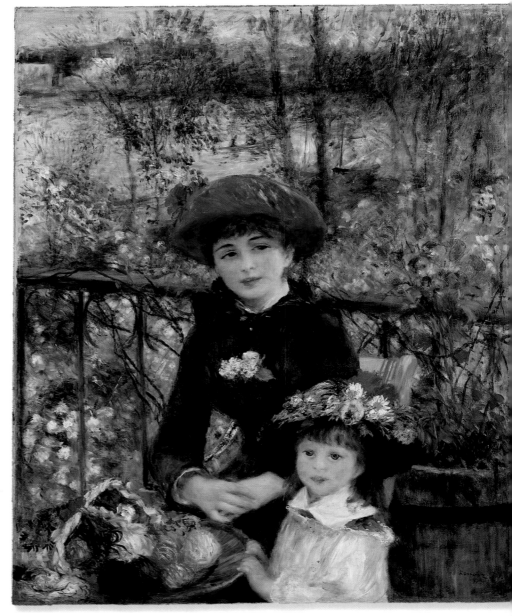

Thick impasto strokes are applied wet-in-wet

FACE AND FLOWERS
Renoir tended to thin his colors more than the other Impressionist artists, applying paint in smooth, feathery brushstrokes. This delicate technique, which allows the white ground to shine through, is used for the girl's translucent pale skin and blue eyes. In contrast, her vivid hat is painted in bold impasto colors, in a virtuoso display of Renoir's flower-painting skills.

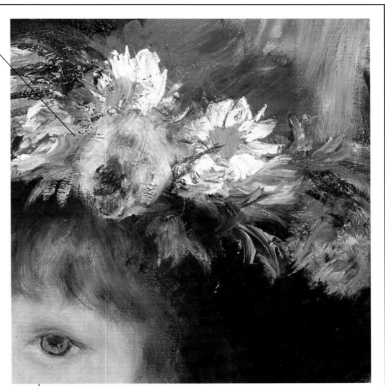

Bright green, made from a mixture of Naples yellow and emerald green

GREEN ON RED
"I want my red to sound like a bell," Renoir said. "If I don't manage it at first, I put in more red, and also other colors, until I've got it ... I haven't any rules or methods." He may not have used any rules, but his understanding of the law of complementary color contrast (pp. 20–21), of how placing colors next to one another altered their appearance, is clearly illustrated in this detail. The blazing red of the older sister's hat is intensified by the bright flash of the green leaves attached to it. The bright red of the hat is also echoed throughout the picture – in the balls of yarn, the large red flower in the little girl's hat, and the thin ribbon running between the older sister's waist and arm.

MODELING THE HANDS
The hands are built up from thin, fluid layers of paint, applied wet-in-wet with a very fine brush. Renoir makes subtle use of the visual effects of warm and cool colors (p. 20) to model the form of the hands – the warm pinks and gold appear to advance, while the cool blue shadows recede.

COLORED YARNS
The boldly painted balls of yarn in the basket seem to represent the range of basic colors from which the picture was painted – and the typical Impressionist palette. The complementaries red and green are featured, but the red is purer and less mixed than that of the hat. Strands of lead white are clearly visible in the balls of pink and red yarn. Contrasting in both texture and color with the surrounding areas, these confidently applied individual strands of paint are the physical equivalents of the actual lengths of yarn.

Café life

THE IMPRESSIONISTS' FASCINATION with modern-life themes often focused on the contemporary urban world of leisure and entertainment. Modern Paris (p. 6) was a city of crowded cafés and restaurants, whose terraces spilled out onto Baron Haussmann's newly widened pavements. Café life, including the new phenomenon of the café-concert, which had the added attraction of popular performers, inspired many Impressionist images. The artists themselves were participants in this world as well as observers of it: they had initially gathered to discuss their ideas in the Café Guerbois (p. 16), later moving to the Nouvelle-Athènes in the Place Pigalle.

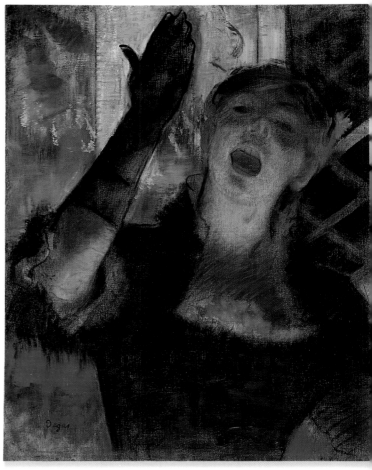

CAFE SINGER
Edgar Degas; c.1878; 21 x 16½ in (53.5 x 41.8 cm)
Degas was as fascinated by the effects of artificial lighting as other members of the Impressionist group were with natural light: this café singer seems to be lit from below by stage lights that illuminate only the bottom half of her face, leaving the rest in shadow. Her head is thrown back, mouth wide open, and a black-gloved forearm is thrust forward. Such a dramatic close-up view, which could not have been achieved from a position in the audience and which isolates the figure from her setting, is rare in Degas' works. Only the trellis behind tells us that she is singing at an outdoor café-concert. Degas made several versions of this image, including a pastel shown at the fourth Impressionist exhibition.

AT THE AMBASSADEURS
Edgar Degas; 1876–78; 11½ x 9¾ in (29.3 x 24.5 cm); lithograph
Degas was a frequent visitor to the Ambassadeurs, an open-air café-concert on the Champs Elysées, where well-to-do crowds watched popular performers such as Emilie Bécat. She was Degas' particular favorite, and he made numerous studies of her, capturing her "epileptic style" – the puppetlike movements she made as she sang. This lithograph shows her at three stages during her act, brilliantly lit by stage lights, and framed by a curtain of leaves.

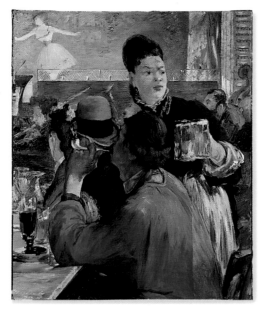

THE WAITRESS
Edouard Manet; 1878–79; 34¼ x 30½ in (97.1 x 77.5 cm)
Manet's image of a café-concert differs from Degas' lithograph (above) in many ways. A worker in his blue smock suggests that this is a far less sophisticated establishment than the Ambassadeurs. And, unlike Mlle. Bécat, the anonymous stage performer is relegated to the background. It is the waitress who is the focus of attention. Armed with beer glasses and caught in mid-movement, she turns her head, presumably in response to a customer's call. The worker stares ahead abstractedly, emphasizing the distinct sense of isolation permeating the crowded café.

A program for the Trianon, a popular nightspot in the Paris of the Impressionists

BOCK BEER MUG
Beer had only been popular in Paris since about 1850, and bock beer mugs became symbols of modern drinking habits, in both life and art.

THE NOUVELLE-ATHENES CAFE

Around 1875, the Impressionist circle switched its allegiance from the Café Guerbois (p. 16) to the Nouvelle-Athènes. One of the regulars, the writer George Moore, referred to their local café as the "academy of fine arts." It served as the site of several paintings, including Degas' *L'Absinthe* (below).

THE READER

Edouard Manet; c.1878–79; 24 x 20 in (61.2 x 50.7 cm)
Using rapid, bravura brushstrokes, Manet depicts a modern young woman sitting alone at a café, drinking a beer and reading an illustrated journal that she has picked from the rack. She is well wrapped up and still wears her gloves, indicating that it is chilly at her outdoor table. But these details tell us no story, and imply no sentimental or moralizing commentary. With his usual detachment, Manet presents a momentarily glanced slice of Parisian life.

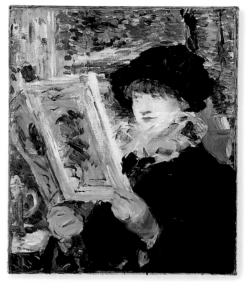

Illustrated newspapers gave an easy, entertaining read

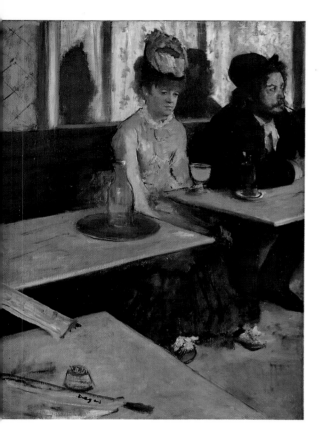

L'ABSINTHE

Edgar Degas; 1875–76; 36¼ x 26¾ in (92 x 68 cm)
Viewed from a nearby table, two down-at-the-heels café regulars stare vacantly over their drinks. Her glass contains absinthe; his contains mazagran, a hangover remedy. Shabbily dressed, the absinthe drinker oozes the lethargy of someone on the way down. The mood is unusually somber for Impressionist art, but has much in common with the social themes of Zola's naturalistic novels.

ELLEN ANDREE

A popular actress, Ellen Andrée posed for *L'Absinthe*, as she did for several other paintings by Degas, Renoir, and Manet. Degas made an exquisitely delicate monotype portrait of her, a detail of which is shown above, at about the same time as the painting was executed. Her companion was modeled by the artist Marcellin Desboutin.

CAFE OBJECTS

Matches and newspapers were available to café customers. Both appear in Degas' *L'Absinthe* (left).

A type of match holder found in 19th-century French cafés

ABSINTHE

Absinthe was a popular working-class drink in 19th-century France. Its notorious intoxicating properties were enhanced by wormwood, although many commercially available absinthes were mixes of anise and mint.

Spoon for mixing absinthe with water

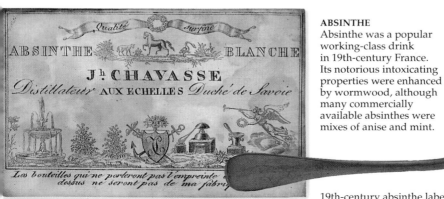

19th-century absinthe label

Renoir at the Moulin

AUGUSTE RENOIR
(1841–1919)
The son of a tailor, Renoir came to art via the craft of porcelain painting (p. 22). Decorative beauty and a sense of joyful celebration characterize his work.

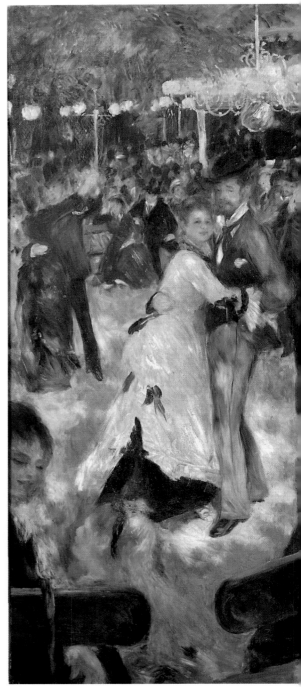

THE PAINTINGS by the working-class Renoir reveal none of the irony and sophisticated detachment that pervade those by the upper-class Manet and Degas (pp. 24–25). He painted for and about pleasure, and as his brother, Edmond, noted, his works are among the "most lovely and harmonious of the age." This large canvas, showing a Sunday dance in Montmartre, is one of the loveliest of all. In the dappled sunlight of the open-air dance space at the Moulin de la Galette, smiling young men and women chat, flirt, and dance on a Sunday afternoon. In the 1870s, Montmartre had not yet become an artists' quarter, and dances at the Moulin were unpretentious affairs enjoyed by the local working girls – shop assistants, florists, laundresses, and milliners. It is these local girls who posed for *The Dance at the Moulin de la Galette*. Yet Renoir's image is not an objective observation of their experience. He has ignored the harsher aspects of reality, and created instead an idealized picture of harmony and serenity.

THE MOULIN DE LA GALETTE
An old mill (*moulin*) on top of Montmartre hill was converted into a café and dance hall. In the summer, dances moved outside into the garden courtyard.

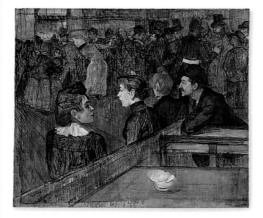

A CORNER IN THE MOULIN DE LA GALETTE
Henri de Toulouse-Lautrec; 1889; 35 x 40 in (88.5 x 101.3 cm)
Painted 13 years after Renoir's celebration of the dance hall's sunny pleasures, Toulouse-Lautrec created a much darker view of the atmosphere at the Moulin de la Galette. The compositional structure is remarkably similar, but three unsmiling girls and a seedy-looking man sit by a counter, while dancers cavort behind.

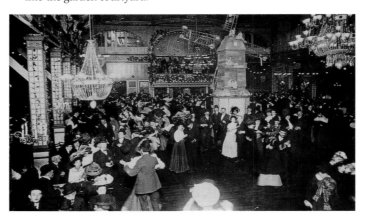

POPULAR DANCES
"Dancing [in Paris] is a function of life ... it is what racing and boxing are in Britain," wrote an American observer in 1867. Public dances (*bals publics*), such as those at the Moulin de la Galette, were among the most popular forms of Parisian entertainment. This photograph shows a crowded dance inside the Moulin in 1900.

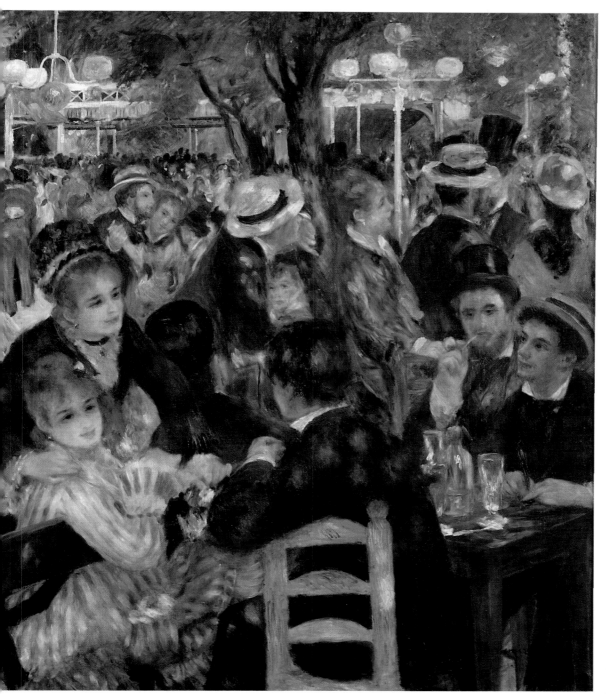

GAS LAMPS AND TREETOPS

Sunday dances at the Moulin de la Galette lasted from three in the afternoon until midnight. As evening fell, the ornate gas lamps were lit. Their white bowls dominate the top of the composition, but Renoir's primary interest lies in the play of natural light that filters through the foliage overhead.

CHANGING SCALE

Behind the large foreground group, the figures decrease rapidly in scale, leading the eye into the background and creating a sense of vast space within the enclosure. Flashes of repeated colors – red, blue, and a buttery yellow – help maintain the painting's surface unity.

PATCHES OF LIGHT

Mottled patches of light break up the forms of the dancers and the dance floor – which one critic compared to "purplish clouds." The effect is at its most dramatic on the man in the foreground.

EXCHANGING GLANCES

Almost hidden beside the tree trunk, a girl glances toward the man in the foreground (in back view), creating a vivid narrative link between the middle distance and the picture's foreground. Cropped off on the bottom left, a young woman glances down at a little child, whose presence adds an air of innocence.

The Dance at the Moulin de la Galette

AUGUSTE RENOIR 1876; 51½ x 69 in (131 x 175 cm)

In his most ambitious work to date, Renoir tackled the problem of showing a large, complex group of figures in the open air. According to his friend and biographer, Georges Rivière, it was painted on the spot, although its large size, and the sketch (right), suggests that it is a studio composition made after open-air sketches. Renoir rented an apartment near the Moulin and attended the Sunday dances. He persuaded his artist and writer friends to pose with local working girls: Rivière, seated on the chair, chats with Morisot's nieces, Jeanne and Estelle.

AN OIL SKETCH
Auguste Renoir; 1876; 25½ x 33½ in (65 x 85 cm)
In this small-scale oil sketch of the dance, probably painted in the open air, Renoir has created the basic compositional elements of the painting above. The canvas is divided into a triangular foreground group, with dancers in the distance. Modifications for the final work included changes to the costumes worn by the figures.

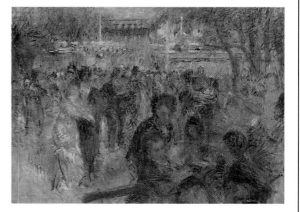

The eye of the camera

"AN IMAGE OF MAGICAL INSTANTANEITY" is how Degas described a photograph. From the moment Louis Daguerre announced details of its discovery in 1838, photography exerted a powerful influence on the visual arts. Its ability to create a likeness had an immediate effect on portrait painters, but its influence soon spread to landscape artists, including Camille Corot. By the time of the Impressionists, technical advances had led to the development of the snapshot camera – it is with "instant," unposed photography that Impressionism is most closely associated. Blurrings, unusual juxtapositions, and the accidental cropping off of figures in snapshots created the sense of movement and spontaneity that the Impressionist artists wanted to achieve. Degas, in particular, often used snapshotlike compositions. He was also inspired by the work of Eadweard Muybridge, whose freeze-frame photographs of humans and animals in motion had revolutionized the depiction of movement in art.

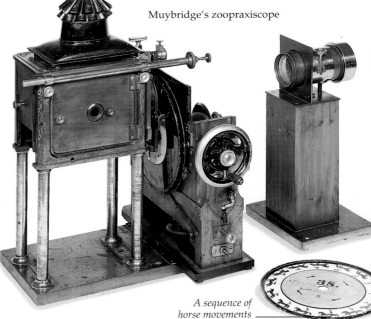

Muybridge's zoopraxiscope

A sequence of horse movements

MUYBRIDGE'S MOVING-PICTURE MACHINE
By taking multiple photographs of moving animals and using fast shutter speeds, Muybridge created sequences that showed successive stages of locomotion (below left). When his photographs were projected through a zoopraxiscope (above), they created cinematic movement.

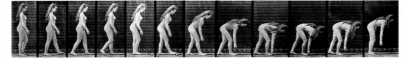

LOCOMOTION: FEMALE NUDE
Degas had known of Muybridge's work since 1878, but it was after the publication of *Animal Locomotion* (in which the above nude appeared) in 1887 that Muybridge's findings on the movement of humans and horses were reflected in Degas' paintings, drawings, and sculptures (pp. 48–49).

ON THE STAGE
Edgar Degas; 1876–77;
23¼ x 16¾ in (59.2 x 42.5 cm);
pastel over monotype
As the little dancers move across the stage, each one displays a different phase in the sequence of choreographed movement. However, the primary photographic influence on this image is not Muybridge, but snapshots. In his unusual off-center composition, Degas has made calculated use of the compositional accidents of snapshot photography (right).

ARABESQUE PENCHEE
Edgar Degas; c.1885–90;
15½ x 27½ in (39.4 x 70 cm); bronze
This bronze figure was cast from one of a series of wax sculptures in which Degas depicted different stages of the classical arabesque movement: the dancer balances on one leg and extends her other limbs. Here, she has arrived at the final, lowest point of the position. The idea of creating figures moving through a sequence of frozen moments has direct links with Muybridge's photographs of the female nude (above).

Bronze cast of Degas' original wax sculpture

BOULEVARD DES CAPUCINES
Claude Monet; 1873; 31¼ x 23¾ in (79.4 x 60.6 cm)
When Monet exhibited this street scene at the first Impressionist exhibition, the critic Louis Leroy dismissed the blurred, distant figures as "black tongue lickings." To the human eye, figures passing below in the street did not appear as blurs. But to the camera's eye, they did. Monet's way of painting movement had little precedent in art – apart from in Corot's soft-edged landscapes of the 1850s. Both Corot and Monet were imitating the blurring effects of contemporary photographs (right); relatively slow shutter speeds meant that only stationary objects remained sharp.

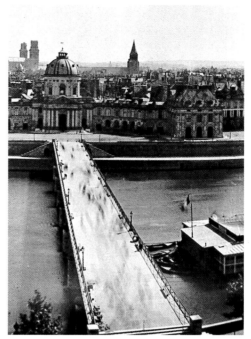

BLURRED FIGURES
There are marked similarities between the figures in Monet's painting and those in this detail from a panoramic photograph, taken by Adolphe Braun in 1867, which have been recorded as faint blurs. This was pointed out by the critic Aaron Scharf in 1968. But at the time, even critics such as Ernest Chesneau, who praised Monet's ability to capture the "antlike swarming ... the instantaneity of movement," failed to associate these painted effects with photography.

PORTABLE CAMERAS
Monet owned four cameras in the 1880s, and Degas bought one of the easily portable Kodak models (left) in 1896.

SNAPSHOTS
The compositional oddities of snapshots such as this, showing Borough High Street in London in 1887 (below), are echoed in Impressionist art.

Kodak snapshot camera of 1888

THE PLACE CLICHY
Auguste Renoir; c.1880; 25½ x 21¼ in (65 x 54 cm)
The startling sense of immediacy created by cropping a figure at the edge of the canvas is illustrated in Renoir's bustling street scene. Where Degas' ballerinas (left) dance out of sight, cut off on the right, Renoir's young woman looms into view from the same position. Again, the left side of the painting remains empty, seemingly waiting for her to pass through. As in the instant photograph (above), moving background figures are reduced to a blur. However, the appearance of spontaneity is deceptive here: Renoir planned his image, working with preliminary studies to achieve the impression of the captured moment.

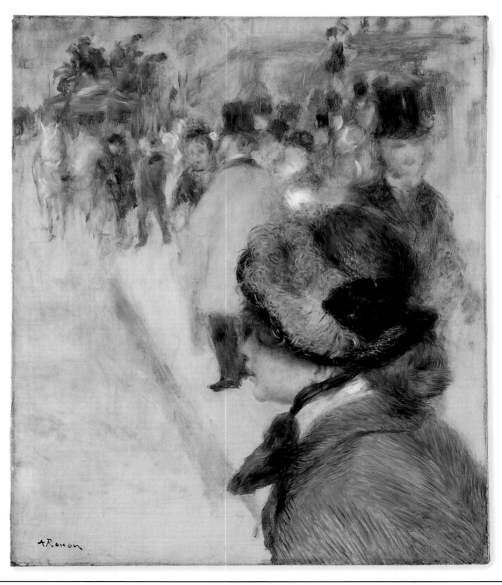

Caillebotte's Paris

GUSTAVE CAILLEBOTTE
(1848–1894)
The hugely wealthy
Caillebotte has unjustly
been remembered only
as a collector. He was
also a distinctive artist,
who began exhibiting
with the Impressionists
in the second group
exhibition of 1876.

THIS MONUMENTAL PAINTING dominated the third Impressionist exhibition of 1877. Yet its tightly painted surface, somber tones, and huge scale appear to be at odds with the small scale, bright colors, and broken brushwork usually associated with Impressionism. Contemporary critics acknowledged the difference: "Caillebotte is an Impressionist in name only. He knows how to draw, and paints more seriously than his friends," one wrote. Caillebotte's methods may differ from his fellow artists, but he has created one of the most arresting Impressionist images of modern life – both a celebration and a critique of the brutal, dehumanizing geometry of Haussmann's urban plan (p. 6). Presenting the scene as if viewed through a wide-angle camera lens, Caillebotte deliberately distorted perspective; his life-size figures loom toward the viewer.

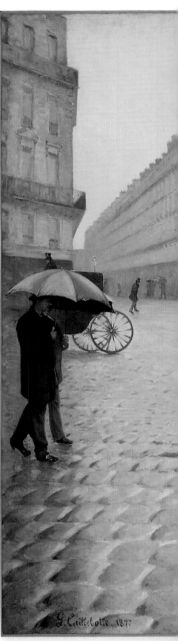

rue de Moscou

rue de Turin

Place de l'Europe

Gare Saint-Lazare

INTERSECTING STREETS
This map of the Batignolles area from Haussmann's atlas shows how the rue de Turin and the rue de Moscou, where *Paris, a Rainy Day* is set, meet at a wide intersection. Gare Saint-Lazare and the Pont de l'Europe nearby were also painted by Caillebotte (p. 33).

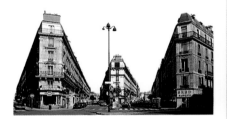

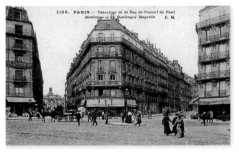

WEDGED BUILDINGS
The intersection Caillebotte painted (right) is shown in the modern photograph above. Both this and the Haussmann crossing in the 19th-century postcard (left) show how the lines of the buildings lead the eye into the distance.

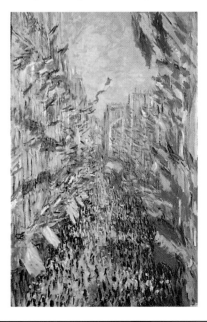

RUE MONTORGEUIL, PARIS
Claude Monet; 1878; 32 x 20 in (81 x 50.5 cm)
Where Caillebotte has frozen a random moment, stressed the geometry of the new Paris, and constructed his painting in stages, Monet's image of a street decked out with flags for a national festival was painted on the spot. Bright flags, and the flicks of paint indicating swarming crowds, obliterate the lines of the architecture and create a vivid sense of movement.

OIL SKETCH OF PARIS, A RAINY DAY
Gustave Caillebotte; 1877; 21¼ x 25½ in (54 x 65 cm)
This oil sketch represents a late stage of Caillebotte's planning for his huge painting. He began with a freehand sketch, perhaps based on a photograph, on which he overlaid ruled perspective lines and drew in zigzag lines to indicate the positioning of figures. Detailed architectural and perspectival studies, drawings, and oil sketches preceded the final composition.

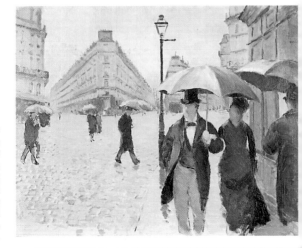

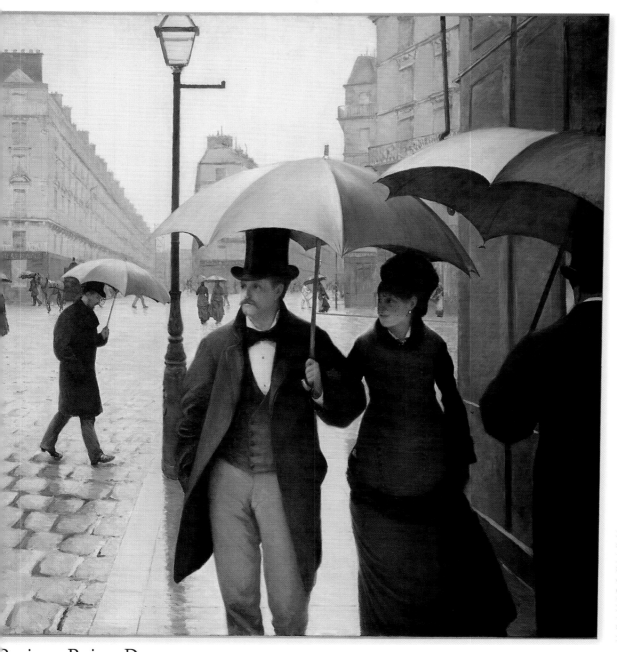

REPEATED TRIANGLES
The rigid geometry of Haussmann's architecture is emphasized by the repeated pattern of triangles on the skyline. These triangles are echoed throughout the composition, from the arrangement of the figures on the left to the triangular umbrella panels.

CLASHING UMBRELLAS
Averting their gaze away from the viewer and from the man who is walking into the frame to their left, the immaculately dressed couple is in danger of becoming involved in an inelegant tangle of umbrellas.

FROZEN FIGURES
The painting's linear structure and the frozen poses of its figures create an unsettling sense of urban emptiness. Despite its apparent realism, the painting appears almost like an architectural model, in which some figurines have been carefully positioned.

NEAR AND FAR
The lamppost not only divides the surface pattern of the painting in half – it also separates two distinctly different types of space. On its right, the figures loom forward; on its left, dramatic tunnellike space zooms backward into the distance.

Paris, a Rainy Day
GUSTAVE CAILLEBOTTE
1876–77; 83½ x 108¾ in (212.2 x 276.2 cm)

Despite the apparent randomness of the image – the right-hand figure is deliberately cut in half to suggest the spontaneous, snapshot nature of the picture – Caillebotte's masterpiece is meticulously planned and ordered. The most obvious element of the linear framework is the positioning of the lamppost that cuts the canvas in half. It forms a cross with the horizon, creating four quadrants. A complex system of proportional relationships exists throughout the painting: the position of each figure was plotted at a significant point in the perspectival plan.

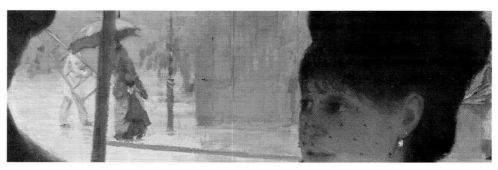

DISTANT DETAIL
What seem to be chance juxtapositions, created by elements overlapping in space, were carefully planned. Between the heads of the couple in the fore-ground, a house painter and a woman step onto the distant pavement. In a deliberate clash of scales, the broad umbrella handle bisects this tiny scene, tying foreground and background together as it does so.

EXQUISITE CLOSE-UP
The highly finished surface of Caillebotte's painting, which had more in common with the technique of Salon artists than with that of the Impressionists, can be seen in the treatment of the foreground woman. A delicately painted, dotted black veil covers her face to her mouth. Behind it, a pearl earring glistens with Vermeer-like clarity.

The age of the train

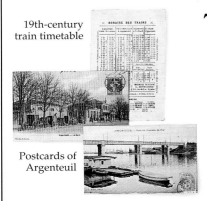

19th-century train timetable

Postcards of Argenteuil

ROUTE TO THE SUBURBS
As the timetable shows, the riverside suburb of Argenteuil was just a 15-minute rail journey from Saint-Lazare. It became the most important center for Impressionism, besides Paris, during the 1870s.

THERE WAS NO MORE AGGRESSIVE SYMBOL of modernity than the new railroads, which had transformed society in the Impressionists' lifetimes. Six stations served Paris, but it is Gare Saint-Lazare that is most closely associated with Impressionism. The appeal of this station, which also inspired writers such as Zola, was understandable. It occupied a vast area in the Batignolles district (p. 16), where the Impressionist artists had originally grouped. Thirteen million passengers a year poured through its doors into the city – most from the suburbs, suddenly accessible to Parisian workers, tourists, and artists alike. Not only was Saint-Lazare at the center of the artists' modern urban world, it was their link to the countryside. Many suburban sites that appear in Impressionist art – Bougival, Marly, Argenteuil, Pontoise, and Auvers – were reached from there. The station was a central motif at the third Impressionist show of 1877; both Monet and Caillebotte showed pictures set at Saint-Lazare (below; right).

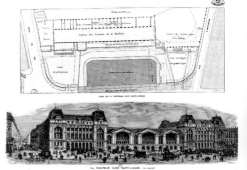

GARE SAINT-LAZARE
The newly built Gare Saint-Lazare inspired both artists and writers. Zola wrote in great detail of the station, and of the general impact of the railroads, in his hugely popular novel of 1879, *La Bête Humaine*.

LE PONT DE L'EUROPE, GARE SAINT-LAZARE
Claude Monet; 1877; 25¼ x 32 in (64 x 81 cm)
Monet displayed seven paintings of Saint-Lazare at the 1877 exhibition. For this canvas, he painted the view from the edge of a platform looking toward the Pont de l'Europe, the new bridge that spanned the railroad tracks. The roofs and chimneys of Haussmann's new apartment buildings appear, set against an overcast sky. As in Caillebotte's painting, the distinctive dark trellis of the bridge bursts into the picture from the right. Monet has softened its harsh lines with clouds of steam, depicted by rapid strokes of light gray and white paint. These stand out against the dark masses of the bridge and trains.

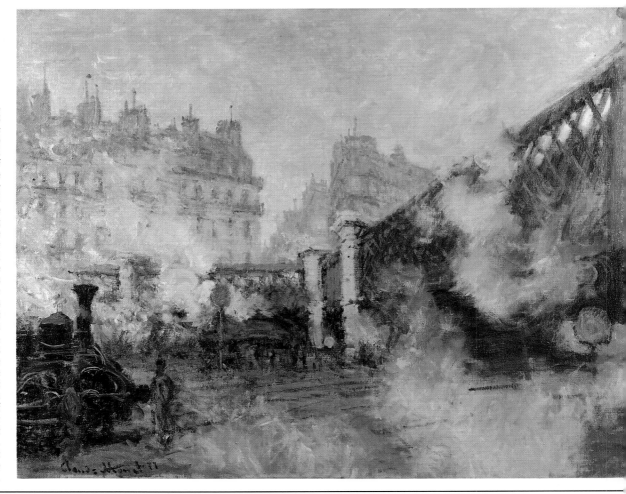

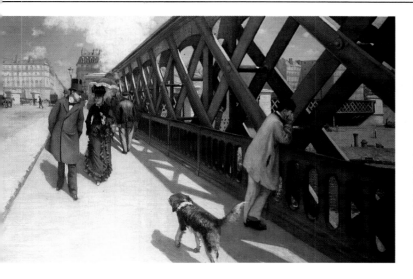

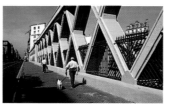

MODERN VIEW

The regular, receding crosses of the Pont de l'Europe's iron trellis dominate Caillebotte's painting. Although the iron crosses have been replaced by concrete ones, this modern photograph of a bridge in Paris shows a similar vista.

LE PONT DE L'EUROPE

Gustave Caillebotte; 1876; 51½ x 71¼ in (131 x 181 cm)

While Monet painted his railroad pictures on the spot, Caillebotte's image of the bridge was, like *Paris, a Rainy Day* (pp. 30–31), the result of numerous studies. As in that painting, Caillebotte uses a funnellike space that recedes dramatically, and carefully positions his figures (and, in this case, a dog) within a precise, architectural framework. The converging perspective lines come together in the head of the top-hatted man, who is thought to be a self-portrait. If so, Caillebotte has made himself the focus of the composition and a *flâneur* – an artist-dandy observing life with sophisticated detachment. Nearby, a manual worker stares through the girders.

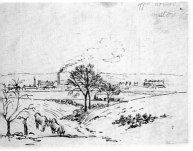

VIEW FROM UPPER NORWOOD

Camille Pissarro; c.1870; ink and pencil on paper

In this sketch from Upper Norwood, London, Pissarro places the train in the middle distance as it is in his painting (right), but here it is viewed from the side and almost obscured by trees. The inclusion of the train and factories adds an aspect of industrial modernity to an otherwise rural landscape.

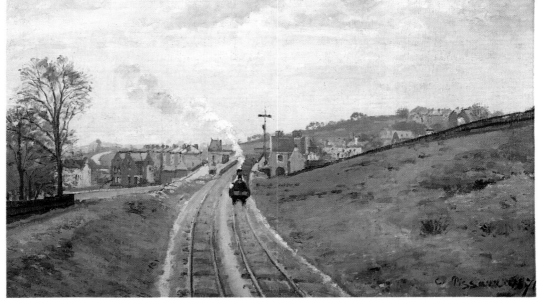

LORDSHIP LANE STATION, DULWICH

Camille Pissarro; 1871; 17¾ x 29 in (45 x 74 cm)

Like Paris, London was transformed by the railroads in the 19th century. Suburbs such as Lower Norwood, where Pissarro stayed from 1870 to 1871 to escape the Franco-Prussian War, had been newly linked by rail to the city; Lordship Lane station, pictured above, was only six years old. Pissarro places the track centrally: its converging lines lead the eye into the painting. The train heads directly toward us, yet its position in the middle distance removes any sense of drama or danger.

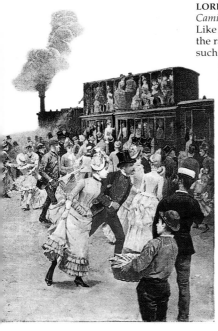

THE RUSH TO THE COUNTRY

This late 19th-century illustration shows enthusiastic middle-class Parisians joining a crowded double-decker steam train as it waits to take them for a Sunday in the country. With the new network of suburban railroad lines, previously remote countryside and the attractive, leafy suburbs outside Paris were within easy reach of all classes.

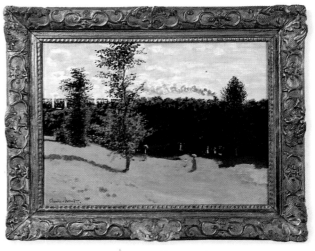

TRAIN IN THE COUNTRYSIDE

Claude Monet; c.1870–71; 19¾ x 25½ in (50 x 65 cm)

Puffing along behind a bank of trees, a double-decker train carries tourists on the Paris to Saint-Germain-en-Laye line, while weekenders promenade on the grassy slopes of a country park. In this little painting, Monet creates a vivid image of the way in which the train brought the city and country together.

Out of town

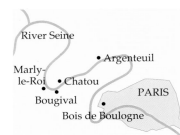

MAP OF THE SEINE
The Impressionists settled and painted in the riverside communities along the banks of the Seine.

ARGENTEUIL REGATTA
This animated illustration depicts a springtime regatta at Argenteuil. The town hosted its first regatta in 1850, and its lively river scenes attracted Monet and his friends during the 1870s.

THE IMPRESSIONISTS COMBINED their interests in painting outdoors and depicting modern life in pictures of Parisians enjoying weekends in the country and in the riverside suburbs, made accessible by the new railroads. In Impressionist landscapes, unlike those painted by *plein-air* forerunners such as Daubigny (pp. 12–13), the human presence is almost always apparent. Even if a landscape is unpeopled, a yacht, a house, or even a haystack indicates the hand of man. Rather than exploring the artist's individual relationship with nature, the Impressionists depicted nature as a social experience. Images abound of picnics and boating parties at resorts along the Seine or in the Bois de Boulogne. However, during the 1870s, the group moved in different directions. The yachting center of Argenteuil, where Monet settled in 1871, and Renoir, Caillebotte, and Manet also painted, became a focus for the "bourgeois branch" of Impressionism. Pissarro settled farther out of Paris at Pontoise and led the way with more rural landscapes (pp. 40–41).

MONET SKETCH
Monet's surviving sketchbooks feature many rough drawings of yachts a Argenteuil and at his family home in Le Havre. This scene was viewed from his floating studio (p. 13).

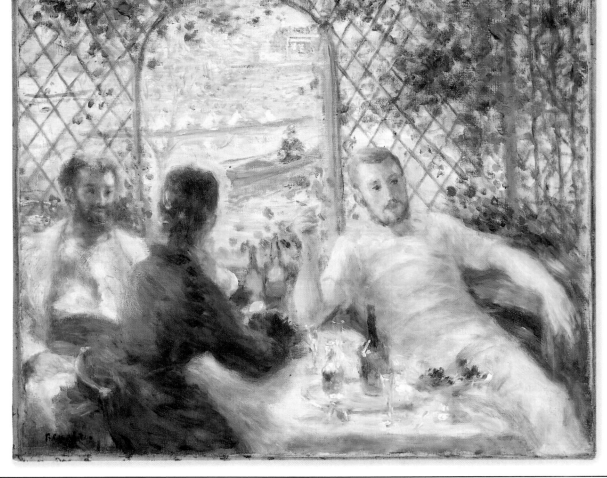

THE ROWER'S LUNCH
Auguste Renoir; c.1880; 21¾ x 26 in (55.1 x 65.9 cm)
This dazzling image of a lazy afternoon by the river was probably painted at Chatou, a few miles south of Argenteuil and "a paradise for anglers and rowers," according to a contemporary edition of the popular *Joanne's* guidebook. Renoir was a frequent visitor in the mid-1870s and regularly dined at the Restaurant Fournaise. This small painting of three boaters in a riverside restaurant celebrates the bourgeois pleasures he would have experienced there. With an apparently effortless technique that parallels the relaxed atmosphere of the subject, Renoir has woven a silken web of color over the canvas with his distinctive, feathery brushstrokes.

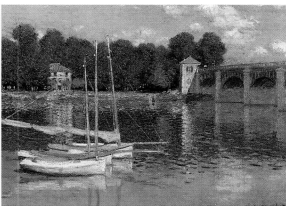

THE BRIDGE AT ARGENTEUIL

Claude Monet; 1874; 23¾ x 31½ in (60.5 x 80 cm)

Painted in 1874, the year of the first Impressionist exhibition, this tranquil river scene shows yachts moored in the "boat basin" near Argenteuil's road bridge. It was just a few minutes away from Monet's house, and he painted more than 70 pictures in the area. Always less interested in figure painting than his friend Renoir, Monet has created a scene of leisure and enjoyment, without a single person being present. The well-balanced composition has a sense of timelessness, but the artist's enduring fascination was with the momentary effects of sunlight on the water. Using broken, horizontal dashes of pure color, painted over the smoothly applied blue of the foreground, he has captured the rippling surface of the Seine.

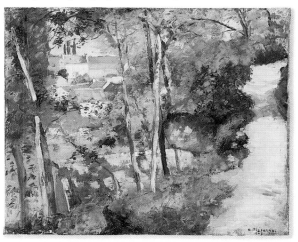

AUTUMN, BANKS OF THE SEINE

Alfred Sisley; 1873;
18¼ x 24¼ in (46.3 x 61.8 cm)

Like Monet and Renoir, Sisley uses the complementary colors orange and blue. Here, their vibrancy evokes the crystal-clear autumn light.

SUMMER'S DAY

Berthe Morisot; c.1879;
18 x 29¾ in (45.7 x 75.2 cm)

The transformation of Paris included the complete remodeling of the Bois de Boulogne, a park on the fashionable western edge of the city. The existing formal layout of the Bois (as it is known to Parisians) was erased and replaced by a vast woodland area dotted with lakes, such as the one shown here. Berthe Morisot enjoyed frequent outings to the Bois and often painted there – this picture is one of three scenes of the Bois shown at the fifth Impressionist exhibition of 1880. Morisot renders no details, but with restless, fluttering brushstrokes she integrates foreground figures with the rippling water behind them.

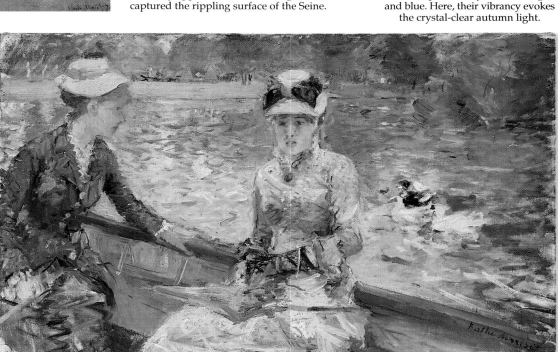

PISSARRO AND CEZANNE

When he returned to France after the Franco-Prussian War, Pissarro settled at the village of Pontoise, 45 minutes by rail from Paris. He was a mentor to many younger painters, including Cézanne, pictured with him here.

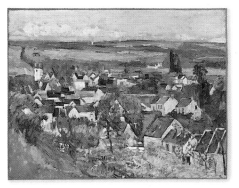

THE CLIMBING PATH, L'HERMITAGE

Camille Pissarro; 1875; 21½ x 25¾ in (54.5 x 65.5 cm)

To Cézanne, Pissarro was a godlike father figure, but the calm, older teacher and the intensely awkward pupil had a profound influence on each other. The interconnecting planes of this work reveal Pissarro's assimilation of paintings such as Cézanne's *Auvers* (above). Selecting the same high viewpoint, he looks down through the trees onto the rectangular roofs, while the path on which he has set his easel runs like a ribbon down the canvas.

AUVERS, PANORAMIC VIEW

Paul Cézanne; 1873–75; 25¾ x 32 in (65.2 x 81.3 cm)

While painting with Pissarro, Cézanne's art began to suggest his preoccupation with the structural and spatial relationships of nature. This concern, which distinguishes Cézanne from the Impressionist artists with whom he exhibited, can be seen in his painting's tightly interlocked geometric surface (left).

Sisley's landscapes

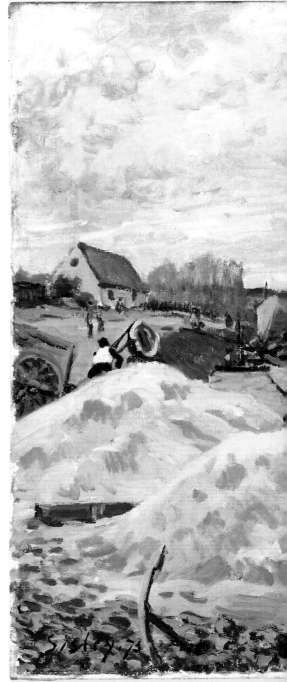

ALFRED SISLEY'S ART focused on the riverside villages to the west of Paris, where he lived. Images of the Seine, particularly of the stretch that curves along between Bougival and Marly-le-Roi (map, p. 34), dominate his paintings. He had little interest in the modern urban scenes that inspired others in the Impressionist group, or in their glittering images of pleasure-seekers at play on the river (pp. 34–35). Unassuming in character and art, Sisley tended to choose more everyday views. He painted this view of the Seine at Port-Marly in 1875, not long after he had moved there. Ignoring the nearby splendor of Louis XIV's formal gardens, he has selected a less obviously attractive local subject – men dredging the bottom of the river for sand, to clear a channel for barges and boats.

ALFRED SISLEY
(1839–1899)
Sisley always remained loyal to the principles of Impressionism. But his work was less popular than that of his friends and he never escaped poverty.

SAINT-MARTIN CANAL
Alfred Sisley; 1872;
15 x 18¼ in (38 x 46.5 cm)
The Saint-Martin canal in Paris was virtually the only site in the city that Sisley painted. Here, the incidental working activity of the canal is viewed from a comfortable distance: on the far bank, dray horses stand quietly while a cart is emptied. As with most of Sisley's paintings made in the 1870s, there is a strong sense of compositional structure, created by the reflected lines of buildings, chimneys, and the raised, silhouetted bridge.

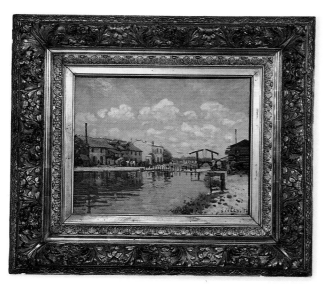

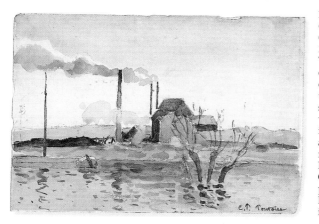

FACTORY ON THE
OISE AT PONTOISE
Camille Pissarro; 1873;
7 x 10 in (17.7 x 25.1 cm); watercolor
The most politically committed of the Impressionists, Pissarro was drawn to images of labor rather than leisure. Like Sisley, Pissarro sometimes painted landscapes that were being transformed by modern industrial activity. In 1873, he made a series of four views of the large, new alcohol-distilling factory that had been built on the banks of the Oise River. This watercolor is a preparatory study for one of them; like Sisley's *The Seine at Port-Marly*, it is an undeniably modern landscape.

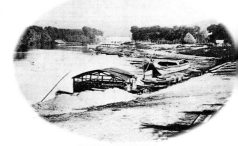

PORT-MARLY IN 1870
Henry Bevan, an amateur photographer, made a photographic record of river life in the 1860s and 1870s. This photograph shows piles of sand, a steadying pole, and a barge.

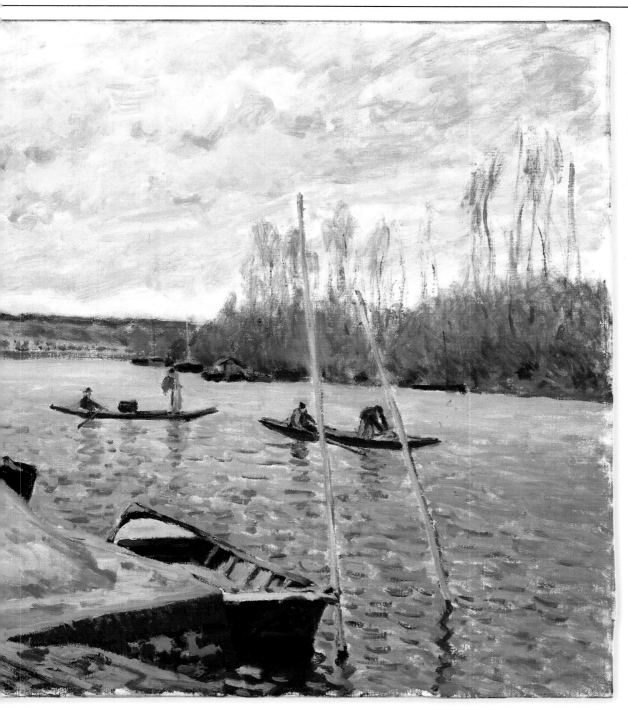

🖌 **CLOUDY SKY**
The sky was of central importance to Sisley: "Not only does it give the picture depth through its successive planes, it also gives movement," he once said. Here, the subtly colored, confidently painted blue-gray clouds seem to move across the sky from left to right, at the same time receding toward the distant horizon.

🖌 **A BEND IN THE RIVER**
To mark the line of the river as it bends in the distance, a single streak of greeny yellow, contrasting vividly with the blue water, has been dragged between converging riverbanks.

🖌 **WORKING BOATS**
Where the Seine at Argenteuil was peppered with leisure craft, here Sisley shows various working barges and dinghies, in use and moored by the bank. Their dark forms contrast with the paler, light-reflecting water. One is tipped up and propped beside the path that runs up to the washhouse.

🖌 **PILES OF SAND**
Unlike the thin, dryish paint of the water detail below, the area of canvas showing the pyramidal mounds of sand is well covered, with more fluid patches of ochres and grays.

The Seine at Port-Marly: Piles of Sand

ALFRED SISLEY *1875; 21½ x 29 in (54.5 x 73.7 cm)*
Sisley chose an overcast day on which to paint this unglamorous, yet harmonious image. Executed on the spot and modified in the studio, the painting has been composed with great care. Piles of sand lead the eye into the painting, while slim poles pass across the picture surface, tying the foreground and background together.

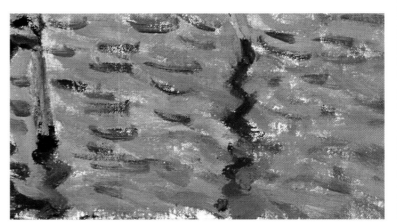

DASHES AND ZIGZAGS
In this detail, taken from the bottom right of the painting, Sisley has used fairly dry paint, dragged across the canvas with square-ended brushes, so that areas of the primed canvas remain uncovered. The choppiness of the water is depicted by boldly simplified dashes of dark blue, cut through by the zigzag of the poles' reflections.

In the garden

THE GARDENS of the Impressionists often appear in their art. Painting in the open air (pp. 12–13) was most convenient at home, and since they had little interest in the wilder aspects of outdoor life, their private gardens provided them with images of cultivated nature that perfectly suited their taste. In celebrating the bourgeois garden, their pictures reflect what had become a national passion for horticulture. The garden played a central part in middle-class life, and this social role is evident in the works of Manet, Morisot, Monet, and Renoir. In their garden paintings, middle-class women rest and stroll, shaded by sun hats or parasols, often with young children. Pissarro, in contrast, focused on the garden as a place of work; in his rustic world, peasants harvest apples, plant peas, and bend over cabbage patches (pp. 40–41).

MONET'S GARDENING BOOKS
The second half of the 19th century saw an enormous rise in interest in plants and flowers. These books are from a 26-volume set of *The Flowers of the Gardens of Europe*, owned by Monet.

THE HOUSE AND GARDEN AT GIVERNY
Monet moved to Giverny in 1883 and immediately began transforming the rather bare plot in which his house stood into a densely planted, colorful garden: "the house ... in pink mortar at the far end of a garden dazzling with flowers," as the art critic Octave Mirbeau described it. The house and garden have been restored and are open to the public.

THE ARTIST AS GARDENER
"My most beautiful work of art is my garden," Monet said. He planted and painted gardens wherever he settled, but it was at Giverny (above) that Monet's passion found its full expression.

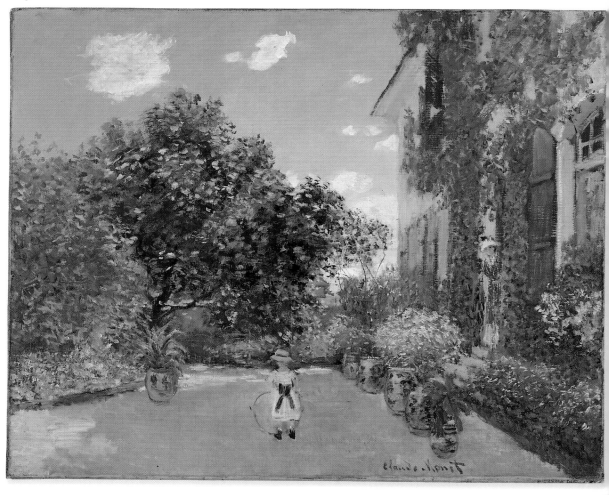

MONET'S HOUSE AT ARGENTEUIL
Claude Monet; 1873; 23¾ x 29 in (60.2 x 73.3 cm)
Surrounded by flowers and foliage, the artist's son Jean plays with his hoop on the sun-dappled gravel in front of the family's home at Argenteuil. Monet's first wife, Camille, peeks out of the ivy-covered house, the blue of her dress echoing the color of the blue-and-white pots. These distinctive Dutch pots appear in pictures of Monet's subsequent gardens, and replicas were installed at Giverny (above). He had moved to Argenteuil in 1871, and this is one of a number of garden paintings made in 1873, after cultivating the garden to his liking.

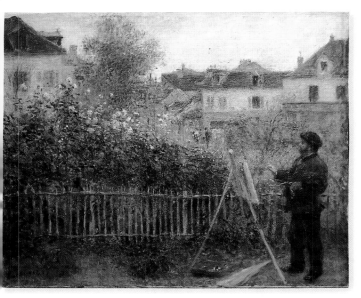

MONET PAINTING IN HIS GARDEN AT ARGENTEUIL

Auguste Renoir; 1873;
18 x 23½ in (46 x 60 cm)

Painting in a style very similar to that used by Monet at the time, with small, broken touches of color, Renoir depicts his friend working at his folding easel in his garden at Argenteuil. (We assume that Renoir has also set himself up with portable equipment.) Behind the hedge bursting with red, yellow, and white dahlias, Renoir has painted the neighboring houses, creating a suburban context that is often omitted from Monet's own garden paintings. Monet's enthusiasm for gardening first blossomed at Argenteuil, and he often painted this garden and the one he developed after his move to a larger house in 1874. Cut flowers also provided subjects to paint indoors.

RENOIR IN THE GARDEN

Like Monet, Renoir worked in his garden until his final days. He is seen here in 1903, already badly crippled by arthritis, which became so severe that he had to have his brushes strapped to his hands to enable him to paint.

THE MONET FAMILY IN THEIR GARDEN

Edouard Manet; 1874;
24 x 39¼ in (61 x 99.7 cm)

Monet's garden at Argenteuil became a center of *plein-air* painting: Manet painted this scene there in 1874. He was staying nearby at his family home and paid Monet a visit. "Enchanted by the colors and light, Manet began an open-air painting of people beneath the trees," Monet later recalled. "Renoir arrived and was also captivated by the moment. He asked me for a palette, brush, and canvas. Then there he was, painting side-by-side with Manet." This incident gives a rare insight into the artists' close working relationships at this time.

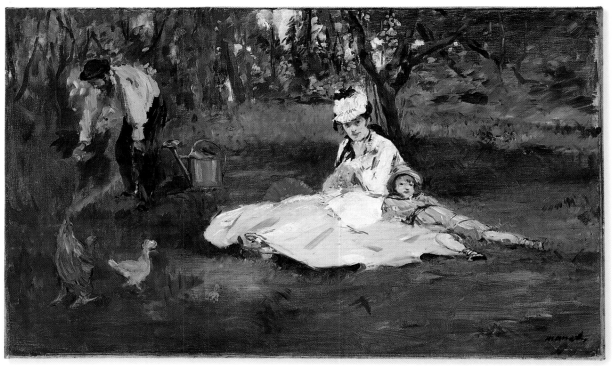

THE BUTTERFLY CHASE

Berthe Morisot; 1874;
18½ x 22 in (47 x 56 cm)

Hovering almost in the center of the canvas, butterfly net in hand, Morisot's sister, Edma, is seen here with her daughter, Jeanne, in the extensive, parklike garden of their country house. While Edma and Jeanne look toward us, another little girl and an unknown woman are apparently oblivious to the artist's presence.

PEASANT AMONG THE CABBAGES

Camille Pissarro; c.1885;
5¾ x 4¼ in (14.5 x 11 cm);
pencil on paper

Similarities between this drawing and Morisot's painting highlight the artists' different approaches. Where Morisot's slender sapling echoes Edma's svelte poise, here the tree's angular branches are mirrored in the woman's bent arms and head. Pissarro roots his figure in the soil; even her stubby fists link her to her cabbages.

Pissarro's workers

CAMILLE PISSARRO
(1830–1903)
Pissarro, pictured here with his wife, Julie, was the only artist to take part in all eight of the Impressionist exhibitions. Yet true success eluded him: "Like Sisley, I remain at the tail end of Impressionism," he once noted sadly.

THE GLEANERS
Jean-François Millet; 1857; 33½ x 43¾ in (85.5 x 111 cm)
Millet was the most famous painter of rural life in 19th-century France, and Pissarro's works were often compared with his. Pissarro admired Millet, but pointed out that his own peasants lacked the romantic and biblical overtones evident in works such as Millet's *The Gleaners* (above).

PAINTING BOURGEOIS men and women idling their days away among the flower beds did not appeal to Pissarro. His interest was in the local peasants who worked the vegetable patches and fields near his rural home of Pontoise, and later at Eragny. Pissarro's art centers on his communion with nature, a communion he saw expressed in its most basic form in the people whose lives were intimately connected to the soil. Until about 1880, the human figure had been mostly an incidental element in his landscapes, but from that time on, figures began to predominate. At the seventh Impressionist exhibition of 1882, he showed a series of peasant pictures that prompted the novelist and critic J.-K. Huysmans to enthuse: "He paints his country folk with no false glamour, simply, as he sees them. His ... peasant girls breakfasting or gathering weeds are truly little masterpieces." Degas was also impressed with Pissarro's peasants: "angels who go to market" is how he described them.

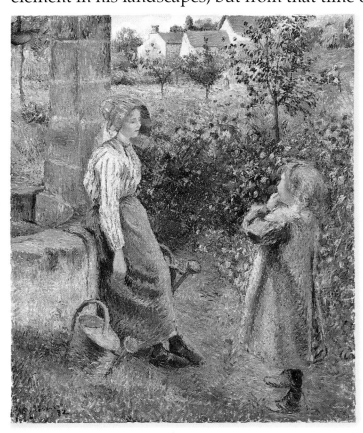

Strong directional light casts deep shadows

The signature and date were added in red to stand out against the green leaves

WOMAN AND CHILD AT THE WELL
Camille Pissarro; 1882;
32 x 26¼ in (81.5 x 66.4 cm)
Leaning against a well, a peasant woman looks across a diagonal of "empty" space toward her young companion. Both the figures and setting are made equally important and unified by color and texture: the reds and browns of the bricks, roofs, and soil recur in the woman's bonnet and girl's blond hair, while paint strokes are distributed evenly across the canvas. Pissarro closed off the view with a high horizon.

STUDY OF A FEMALE PEASANT HARVESTING
Camille Pissarro;
c.1874–76; 9 x 15½ in (22.9 x 39.5 cm); charcoal on paper
This drawing was probably made while Pissarro was staying at a friend's farm in Brittany. The woman's pose is strongly reminiscent of Millet's gleaners (above), but the harsh angularity of line, typical of Pissarro's drawings in the 1870s, denies any trace of sentimentality.

Peasant Women Planting Pea Sticks

CAMILLE PISSARRO

1890; 15¼ x 23¾ in (39 x 60.2 cm); gouache with black chalk on paper

Pissarro completed at least 35 fans, and this is one of his most beautiful. For him, as for Degas and Morisot, the painted fan was an art form rather than a functional object, and he rejected traditional decorative designs for imagery that echoed his paintings. In this idyllic picture of rural life – far removed from his earlier, more down-to-earth depictions – the reality of labor is transformed into a graceful, rhythmic dance.

CLOSE-UP DETAIL
Pissarro's daring use of color can be seen in this actual-size detail of the front figure. Boldly applied hatched lines of pale pink are used for the face and neck, with dabs of bright red gouache under the nose and mouth. The bent arm is modeled with cross-hatched lines of pink, pale green, and red.

DISTANT LANDSCAPE
The high ground on which the women plant their pea sticks overlooks a village, probably Eragny-sur-Epte, where Pissarro lived from 1884 until his death in 1903.

PINK BLOSSOM
Pissarro's use of pastel colors, such as in the delicate pink blossom above the women, emphasizes the decorative beauty of the fan.

CURVED TRUNK
Echoing the undulating contours of the women's bodies, which twist as they force the pea sticks into the soil, the tree trunk also acts as a framing device.

GATHERING STICKS
As if to give the scene a sense of narrative continuity, Pissarro has included a young woman making her way toward the main group.

Patrons and supporters

THE IMPRESSIONISTS' UNCONVENTIONAL works were difficult to sell. Manet, Morisot, and Caillebotte were wealthy enough not to rely on earning an income from their art, and supported their friends with loans and purchases. Even so, the others suffered dire financial hardships. Among the few enlightened buyers were a publishing tycoon, Georges Charpentier; a department store magnate, Ernest Hoschedé; and two doctors, Paul Gachet and Georges de Bellio. But one name dominates the commercial history of Impressionism: Paul Durand-Ruel. He championed and sold works starting in the early 1870s, but it was not until 1886, when he introduced Impressionism to a new American audience, that the years of struggle turned to success.

PAUL DURAND-RUEL
(1831–1922)
"A true picture dealer should also be an enlightened patron; he should, if necessary, sacrifice his immediate interest to his artistic convictions," wrote Durand-Ruel. The Impressionists' first and most loyal dealer, he came into contact with them in 1870, when he met Pissarro and Monet in London. There were bad feelings when times were hard, and some artists placed their works with rival dealers, but it was through Durand-Ruel that they finally found fame.

MADAME CHARPENTIER
AND HER CHILDREN
Auguste Renoir; 1878; 60½ x 75 in (153.7 x 190 cm)
An economic crisis forced Durand-Ruel to stop buying in 1874, but the following year he presided over a public auction of Impressionist works. It was a disaster: the police had to be brought in to control the crowd, and most bids hardly covered the cost of the frames. But one buyer, Georges Charpentier, was particularly taken with Renoir, and the artist was invited to Mme. Charpentier's illustrious "salons," where artists, writers, and left-wing politicians gathered. Entry into the Charpentiers' moneyed world introduced Renoir to many potential clients. And when this magnificent portrait of Mme. Charpentier and her children was shown at the Salon of 1879, he found official recognition, too.

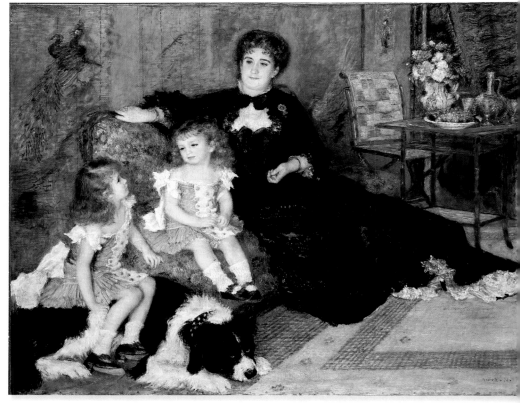

STUDY: PORTRAIT OF EDMOND RENOIR
Auguste Renoir; 1881; 17¾ x 14 in
(45.2 x 35.4 cm); ink and crayon on paper
This drawing by Renoir of his younger brother was made to illustrate a story by Edmond for *La Vie Moderne* ("Modern Life"), a magazine founded by the Charpentiers in 1879. Edmond organized a number of the Impressionist artists' solo shows in the magazine's offices.

DURAND-RUEL'S SALON
Here is a rare glimpse of Impressionist paintings in a contemporary residential setting. Renoir once said, "Painting is done to decorate walls ... a picture should be something likable, joyous, and pretty – yes, pretty." Decorating the walls of Durand-Ruel's elegant salon, to the left of the doors, is Renoir's *Dance in the City.*

PISSARRO'S LETTER SKETCH
Writing to his son in 1886, a poverty-stricken Pissarro complained that he had found a buyer for a painting, but that it was in Durand-Ruel's possession. He enclosed this sketch of a picture he painted for the dealer.

DURAND-RUEL,
16 RUE LAFFITTE
11 RUE LE PELETIER
PARIS.

NEW YORK OFFICE,
315 FIFTH AVENUE (cor. 32d Street)

April 12th, 1893.

M. A. Ryerson Esq.,
to
Messrs. Durand-Ruel.

Lépine	- No. 341	- "L'Ile de la Grande Jatte"	- $300.
Lépine	- No. 441	- "Place de la Concorde"	- 300.
Lépine	- No. 339	- "Le Pont d'Austerlitz"	- 350.
Lépine,	- No. 440	- "Pont de Notre Dame"	- 300.
Sisley	- No. 434	- "La Seine à St. Mammes"	- 350
Sisley	- No. 917	- "Aprèsmidi de Septembre"	- 45
Monet	- No. 976	- "Meules, effet de neige"	- 1.5

Messrs. Durand-Ruel
to
M. A. Ryerson Esq.

1 Sisley - No.2366 - -

Balance in favor of Messrs. D

2 S. Colsmans Shipped besides.

Ryerson and Durand-Ruel here exchange paintings by Sisley, Monet, and Lépine (p. 62)

TABLEAUX MODERNES
DE PREMIER ORDRE

Bernheim Jeune & C^ie
EXPERTS

MRS. POTTER PALMER
Wealthy businessmen and women of the United States created the commercial success that most of the Impressionists began to enjoy by the 1890s. This photograph shows Bertha Palmer, a leading light in Chicago society and an enthusiastic collector of contemporary art. In 1889, while visiting Paris, the Palmers were introduced to Mary Cassatt, also an American. Through her they came to know the work of the other Impressionists and amassed a huge collection of their works. Many were left to the Art Institute of Chicago in 1922.

NATIONAL
ACADEMY OF DESIGN.
———
SPECIAL EXHIBITION.
———
Works in Oil and Pastel
by
THE IMPRESSIONISTS
OF PARIS.
MDCCCLXXXVI.

Durand-Ruel's National Academy of Design exhibition catalog

FROM PARIS TO NEW YORK
Since success eluded him in France, Durand-Ruel sought a new market in the United States. In 1886, he exhibited 289 Impressionist works at the American Art Association in New York, transferring the successful show to the National Academy of Design. Just two years later, he opened his New York office on Fifth Avenue.

THE PALMER GALLERY
In 1885, with a fortune made from department stores and hotels, the Palmers bought an extravagant mansion on Lake Shore Drive, overlooking Lake Michigan. One of its rooms was this spacious gallery, hung with three tiers of paintings. The extent of their purchases can be gauged by the fact that Mrs. Palmer bought 25 Monet paintings in 1891 alone. Her favorite possession was Renoir's *Jugglers at the Cirque Fernando*.

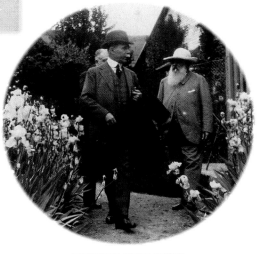

RYERSON AND MONET
Though he was opposed to Durand-Ruel selling his works in the United States, Monet owed his long-awaited success to American buyers. He is seen here in his Giverny garden with Martin A. Ryerson.

Domestic lives

THE FEMALE IMPRESSIONISTS have been long overlooked by art historians – partly because their sex excluded them from many aspects of the public world of modern Paris, the central subject matter of most of their male colleagues' work. Respectable women such as Berthe Morisot, Mary Cassatt, and Marie Bracquemond were not free to paint in the boulevards and café-concerts, and were to a great extent confined to the private world of the family, house, and garden. The daily rituals and relationships of modern bourgeois life became the focus of their art, and family members were their models. The more intimate life of the home was not an exclusively female artistic domain, of course; Renoir, Monet, Caillebotte, Degas, and Pissarro each painted domestic scenes, and all the major Impressionists, except Degas, produced fine examples of still life.

AFTERNOON TEA
Marie Bracquemond; 1880; 32 x 24¼ in (81.5 x 61.5 cm)
A contributor to three of the Impressionist exhibitions, Marie Bracquemond executed most of her work in her garden. Her career was stifled by the professional jealousy of her artist-husband, Félix

FIVE O'CLOCK TEA
Mary Cassatt; c.1880; 25½ x 36½ in (64.8 x 92.7 cm)
Caged between the striped wallpaper and the looming tea service, a young visitor empties her cup as her hostess leans back pensively. With detached precision, Cassatt captures a moment of silence in a refined afternoon ritual.

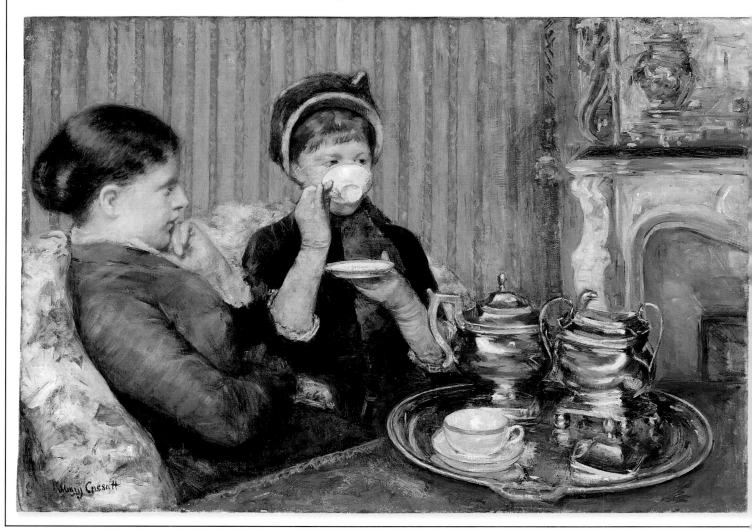

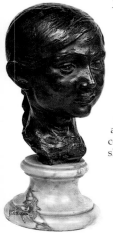

JULIE MANET
Berthe Morisot; 1886;
10½ in (26.7 cm); plaster
Morisot had married Eugène Manet, the artist's brother, in 1874, and their only child Julie appears in her mother's art from infancy. In this charming portrait, Morisot tackled a medium in which she could not exploit her skills as a colorist.

GETTING OUT OF BED
Berthe Morisot; 1886;
25½ x 21¼ in (65 x 54 cm)
The decorative sensuousness of this boudoir scene evokes the world of the 18th-century Rococo masters – an effect underscored by the Louis XVI bed. Despite the peaceful atmosphere, the surface is composed of extraordinarily animated slashes of white, red, blue, and green paint.

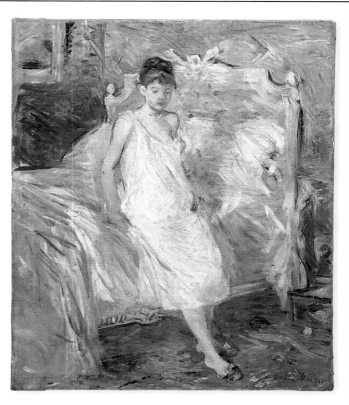

MOTHER AND CHILD
Mary Cassatt; 1891;
14¾ x 11 in (37.2 x 27.6 cm); pencil on paper
The intimate daily rituals of mothers and babies recur in Mary Cassatt's art from the 1870s. This delicate drawing is a preparatory study for one of a set of ten color prints featuring women's domestic routines. Cassatt first exhibited them in 1891 (pp. 56–57). These were influenced by Japanese prints, which Cassatt admired and collected.

WOMAN DRYING HER HAIR
Camille Pissarro; c.1885; 7 x 4½ in (17.7 x 11.4 cm); chalk on paper
Pissarro made this powerful chalk drawing in the mid-1880s. His interest in the human figure had begun to dominate his art, and he made many drawings and paintings of the daily activities of rural women – sewing, washing, and sweeping the floor. Unlike Cassatt's starched tea drinkers (left) or Morisot's elegant, slim-armed young model (above), Pissarro's woman has the solid, muscular physique and pose of a worker.

Still-life painting

Still-life painting had low status at the Salon (p. 18) because it lacked any serious moral aspect. Though the Impressionists held no such prejudices, they painted still lifes relatively rarely, perhaps because as a subject it offered neither modernity nor the opportunity to paint open-air effects.

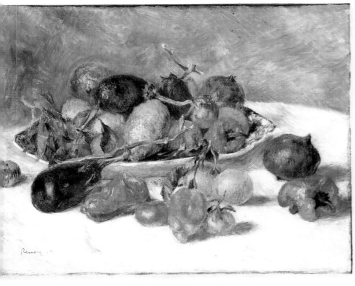

FRUITS FROM THE MIDI
Auguste Renoir; 1881; 20 x 25¾ in (50.7 x 65.3 cm)
Around 1880, Renoir found that there was a reasonable market for still lifes, and he painted a number of them at that time. Here he has exploited the lush range of color and texture in the exotic mix of pomegranates, eggplants, tomatoes, and red peppers – as the title indicates, technically they are fruits rather than vegetables. Renoir has painted the white tablecloth tinged with the feathery touches of color cast by the foods.

THE PLATE OF APPLES
Paul Cézanne; c.1877;
18 x 21½ in (45.8 x 54.7 cm)
Unlike his Impressionist friends, Cézanne painted many still lifes – about 200 in all. His art focused on the spatial relationships that occur in nature, and still-life painting allowed Cézanne to arrange those relationships himself, as in this canvas (right).

Morisot's bourgeois women

BERTHE MORISOT (1841–1895)
Morisot, a significant Impressionist artist, was largely dismissed as an amateur because she was a woman. Her death certificate noted that she was "without any profession."

THE FLUENT DELICACY AND RAPID, SKETCHY BRUSHSTROKES of Berthe Morisot's works were seen by some critics as "slapdash." To others, such as the critic Paul Mantz, her "freshness and improvisation" made her the "only Impressionist in the group." Her combination of extraordinarily free and confident brushstrokes with an exquisite subtlety of color is clearly illustrated in this lovely painting, with its nuances of pearly grays, pastel pinks, and pale blues. Morisot's limited subject matter reflects her sex and social position as well as her artistic interests. Neither working-class themes nor the public side of Parisian life appear in her art. The core of her work consists of private images of elegant women from her own social world. They are often depicted at home at different times of the day: rising from bed, relaxing in the garden, or, as in *Lady at Her Toilette*, dressing in their boudoir for an evening at the opera.

Lead white Red lake Ivory black Cobalt blue Viridian green

ARTIST'S PALETTE
The pigments used have not been analyzed, but as usual with Morisot, white is the most significant color. Other pigments probably include red lake, ivory black, cobalt blue, viridian green, chrome or cadmium yellow, and yellow ochre.

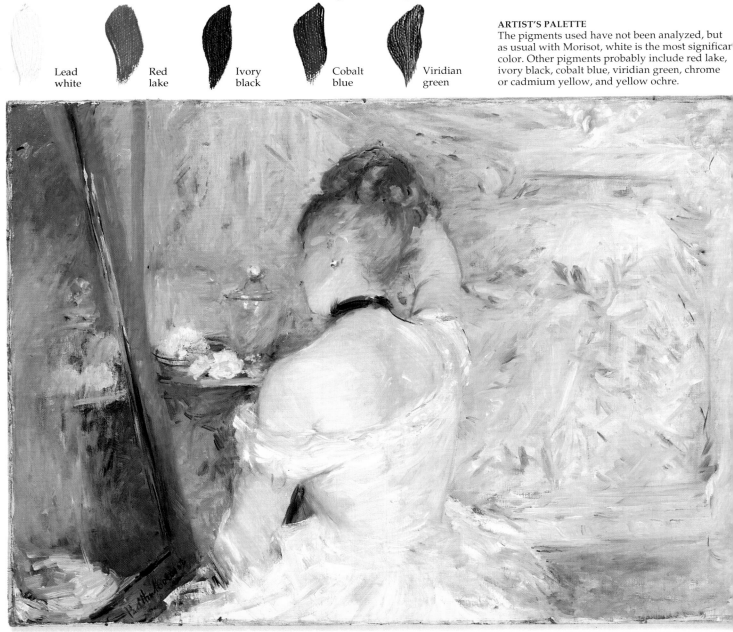

Rapidly worked strokes of gray, yellow, and white suggest the rose corsage

Pearl earring, painted with a squiggle of black and a dab of white

A line of dense black is painted over the first gray-black of the choker

BLURRED PROFILE
In her effort to create an apparently spontaneous image and to "capture something transient," Morisot allowed the process of her painting to remain visible. She did not cover up "mistakes," such as the way the black velvet choker is smudged up into the woman's chin, or the fact that the fine, pale paint of the flesh-tones has run over, rather than under, the black. Wiping and blotting her paints as she worked, she suggests rather than defines form, blurring edges, as she has done in the profile – creating the painterly equivalent of movement.

FEMININE TOUCHES
In this boudoir still life, Morisot displays powder puffs, a pretty jar, and the pale yellow rose that the woman will pin to her dress when she has finished her toilette. The clear glass jar is rendered with just a few diagonal strokes, some dabs of white highlight, and an outline, rapidly drawn over the mottled paint of the wallpaper.

FLOWER ANALOGIES
Flowers feature in many of Morisot's paintings, and floral references recur in descriptions of her work: the critic Fairfield Porter likened her brushstrokes to "petals falling from overblown peonies."

The woman's elbow is indicated by rapid, smudged scribbles

Lady at Her Toilette
BERTHE MORISOT
c.1875; 23¾ x 31½ in (60.3 x 80.4 cm)

This was one of the most well-received paintings displayed at the fifth Impressionist exhibition of 1880. Critics were enchanted by the opalescent delicacy of Morisot's work, which they saw echoing the decorative beauty of paintings by 18th-century Rococo masters such as Jean-Honoré Fragonard – to whom Morisot was thought to be related. Rapturous descriptions of the painting focused upon her remarkably subtle color harmonies: "She grinds flower petals onto her palette," wrote the critic Charles Ephrussi, "so as to spread them later on her canvas with airy, witty touches, thrown down almost haphazardly."

UNCOVERED CANVAS
Morisot wanted her paintings to achieve the fresh, informal appearance of water-colors and pastels. The pale ground of the canvas is left partially uncovered here, both adding to the painting's luminosity and making the diagonally hatched and blurred brushstrokes appear like pastel dragged across paper.

Days at the races

HORSE RACING WAS the most fashionable
spectator sport of Parisian high society in the
Impressionists' day. Imported from England
in the 1830s, its popularity was bound up with
a craze for everything English that gripped the
French upper classes. As part of the Emperor's
plans for his modern capital, the new Longchamp
racetrack had been completed in 1857 in the Bois
de Boulogne, on the outskirts of the city. But this
aspect of Parisian life was ignored by most of
the Impressionists: the racetrack appears only
in the work of Manet and Degas, who both disassociated themselves
from "mainstream" Impressionism. While Manet made only a few
images of the turf, focusing on the drama and social spectacle of the
race, in Degas' art the movement of the racehorse was a major theme.

MAP OF THE BOIS
The Longchamp racetrack was
located in the Bois de Boulogne, just
six miles (ten kilometers) from the
city center. It was also in easy reach
of the upper-class residents of Paris'
fashionable western suburbs.

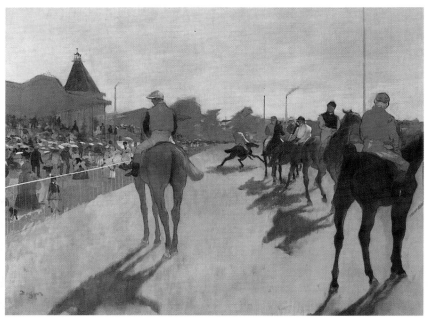

**JOCKEYS IN FRONT
OF THE STANDS**
*Edgar Degas; c.1866–68;
18 x 24 in (46 x 61 cm)*
Degas preferred to depict
the moments before the
race began, when the
individual movements of
the horses could be seen
most clearly. Where Manet
evokes speed in a painterly
blur of action, Degas'
draftsmanship shows
the horses' potential for
speed. Like Japanese
artists (pp. 54–55), he has
created a flat pattern on
the canvas, setting the
contours of the horses
against the pale triangle
of the receding racetrack.

The Races at Longchamp
EDOUARD MANET
c.1864; 17¼ x 33¼ in (43.9 x 84.5 cm)
Manet's stunning painting captures the
drama of a race at Longchamp, as the closely
grouped horses gallop past the finishing post,
directly toward the viewer. This dangerously
involving, head-on view is thought to be the
first of its kind in the history of art. The precise
geometry of the finishing post, cut through
by the distant horizon, emphasizes the great
speed of the horses, as their thundering hooves
disappear in a trail of dust. With his virtuoso
shorthand technique, Manet has reduced the
elegant crowd to an animated mass of dots –
only a few figures stand out as individuals.

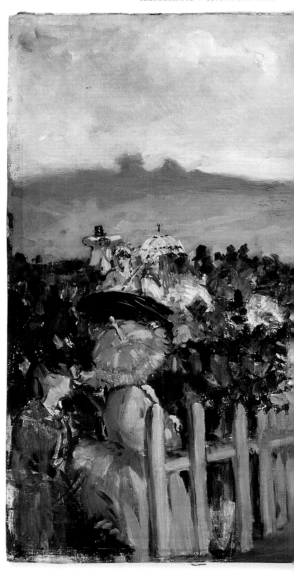

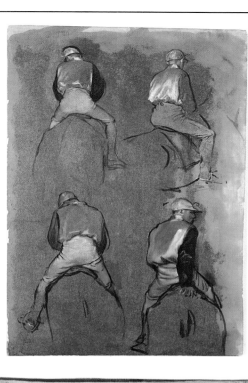

STUDIES OF A HORSE
Edgar Degas; c.1868–70; 12 x 9½ in (30.5 x 24.4 cm); graphite on paper
Degas produced 45 paintings, 20 pastels, some 250 drawings, and 17 sculptures on the racehorse theme. He constructed the finished images in his studio, taking poses from his stock of studies, such as this back view. It may be related to the left-hand horse in his canvas (far left).

FOUR SKETCHES OF A MOUNTED JOCKEY
Edgar Degas; 1866; 17¾ x 12½ in (45.3 x 31.6 cm); gouache, ink, and oil on paper
In this superb study, Degas uses gouache, ink, and oil paint to explore the way the sheen of the jockey's silks changes as he moves.

HORSE REARING
Edgar Degas; c.1890; 10¾ x 16¼ in (27.5 x 41 cm); bronze
Degas' wax sculptures of horses were not made to sell, but to try out new poses – reflecting his keen interest in Muybridge's photographs (p. 28) of horses in motion. They were later cast in bronze.

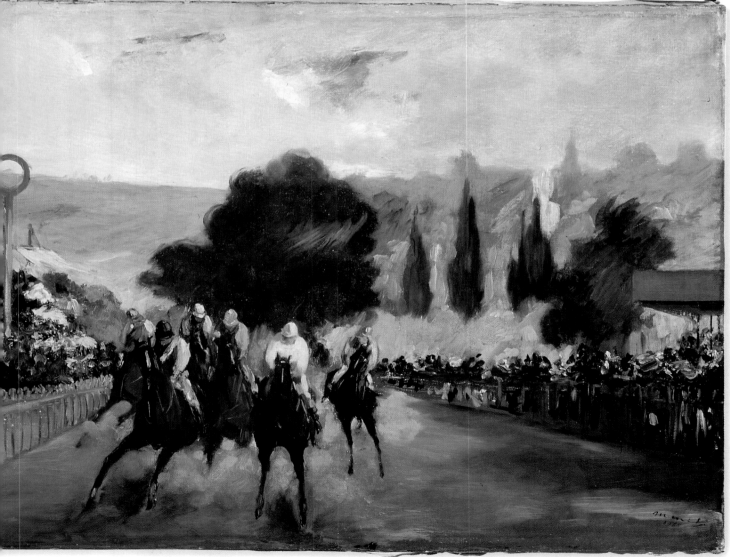

At the theater

THE PARIS OPERA
Designed by the architect Charles Garnier to be one of the crowning glories of modern Paris, the magnificent Opéra was completed in 1875.

ELEGANT FAN
At the theater, a fan was both a fashion item and a practical necessity.

A CLOSER VIEW
Binoculars such as these were used by both male and female spectators for close-up views of the stage and audience.

IN THE 1870S PARIS was the theatrical capital of Europe. Like the café-concerts that spread through the city (p. 24), opera houses and theaters were crowded nightly. Some were grander than others, but most had rows of boxes and balconies (*loges*) that presented obvious pictorial framing devices. Orchestra seats, which offered no such compositional framework, are rarely featured in Impressionist art. Isolated in their loges, the elegant audiences, particularly the women, were part of the theatrical spectacle. The male escort usually sat behind his partner, so that she could be shown to her best advantage, as in Renoir's *La Loge*. Like Renoir, Cassatt focused on the audience, while Degas' interest was in the ballet dancers who performed on stage.

LA LOGE

Auguste Renoir; 1874; 31½ x 25 in (80 x 63.5 cm)
One of the best-loved Impressionist images, this painting even escaped criticism when shown at the first Impressionist exhibition. The woman in her splendid dress rests her opera glasses on the velvet ledge of the box as she returns the viewer's gaze – not in the challenging manner of Manet's *Olympia* (p. 18), but as if acknowledging admiration. Theater boxes were places both to see and be seen, and her male companion has raised his binoculars to observe the audience, rather than the stage. This social world was not frequented by the working-class Renoir: his brother, Edmond, and a model posed as the couple.

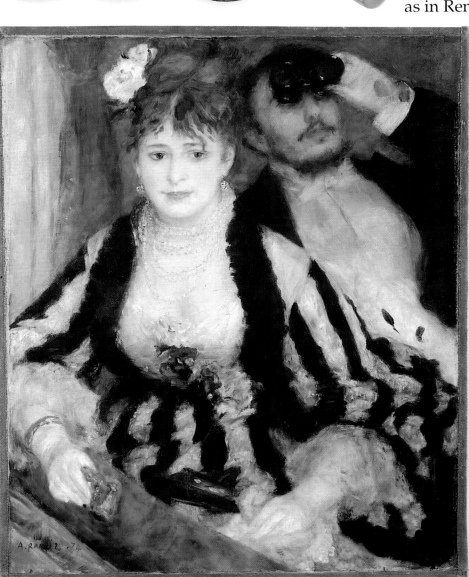

BOUQUET IN A THEATER BOX
Auguste Renoir; c.1871; 15¾ x 20 in (40 x 51 cm)
In this unusual still life, Renoir has painted a nosegay of rosebuds lying on a pink velvet theater-box chair. Nosegays, wrapped in white paper, were common fashion accessories carried by women at the theater and opera, often given to them by their male escort. Although contextual references have been removed, this bouquet clearly belongs to Impressionist Paris.

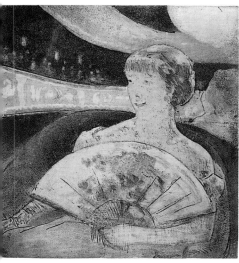

IN THE OPERA BOX
*Mary Cassatt; c.1880; 13½ x 10½ in
(34 x 26.7 cm); etching and aquatint*
Cassatt tackled similar compositions in oils, pastels,
and prints: this etching echoes the painting below.

Cassatt and Degas

At the invitation of Degas, the American
artist Mary Cassatt first exhibited with
the Impressionists in the fourth show of
1879, showing at least three pictures of
young women in theater boxes. The
artist and critic Diego Martelli noted
that in her modern sense of movement,
light, and design, she might be a student
of Degas. Indeed, she later wrote: "The
first sight of Degas' pictures was the
turning point in my artistic life."

TWO YOUNG WOMEN IN A LOGE
Mary Cassatt; 1882; 31½ x 25 in (80.3 x 64 cm)
As in *Woman in a Loge* and *In the Opera Box* (left), Cassatt has used the pictorial format of
half-length sitters in the foreground, with reflections – of a shoulder and sweeping tiers of
balconies and boxes – in the mirror behind. But unlike the smiling, relaxed demeanor of the
women in the earlier images, these two well-bred young ladies (modeled by Geneviève
Mallarmé, daughter of the Symbolist poet, and an American visitor) appear stiff and self-
conscious about the idea of being on public display. One shields her face protectively behind
her colorful fan, whose semicircular shape dominates the composition. Its line carries on
through her elbow and hand, and along her companion's shoulder, continuing through the
curve of the nosegay – suggesting a complete circle that binds the two young sitters together.

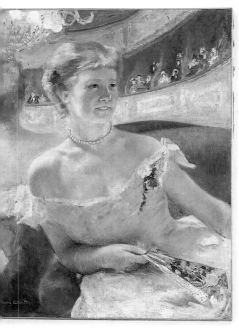

WOMAN IN A LOGE
Mary Cassatt; 1879; 31½ x 23 in (80.3 x 58.4 cm)
Originally set in a green frame, this painting was
singled out for lavish praise at the 1879 exhibition:
reviewers focused on the lighting and reflections.
It probably shows Cassatt's sister, Lydia.

**BALLET AT THE
PARIS OPERA**
*Edgar Degas; 1876–77;
14 x 28½ in (36 x 72 cm);
pastel over monotype*
While Renoir and
Cassatt pictured
spectators, Degas
chose to focus on
the performers. His
earliest ballet pictures
are viewed as if from
the orchestra pit, as
in this striking two-
tiered composition.

Degas' dancers

EDGAR DEGAS
(1834–1917)
Although he was
a prime force in the
Impressionist shows,
Degas never thought
of himself as an
Impressionist. He was
an outsider, stylistically
and socially, until his
friendship with Mary
Cassatt (p. 51).

"THEY CALL ME the painter of dancers,"
Degas is reported to have said, "without
understanding that for me the dancer has been
the pretext for painting beautiful fabrics and
rendering movement." Over half of his pastels
and oils depict the ballerinas who performed
between the acts at the Paris Opéra. From the
1870s, he drew and painted them obsessively –
on stage, in their dressing rooms, in rehearsal,
and at rest. Intimate, behind-the-scenes subjects
far outnumber the images showing the dancers
in performance. However, these intimate images
are also impersonal: Degas scrutinized and
documented the movements of the little "rats"
– the adolescent dancers of the corps de ballet
– with detachment. The
modern, realist equivalent
of the classical nude, they
posed for him repeatedly in his studio. Degas was also
intrigued by the social world backstage at the Opéra, where
rich and powerful male "protectors" of the young dancers
hovered and prowled in dressing rooms and in the wings.

DANCER STRETCHING AT THE BAR
Edgar Degas; c.1877–80; 12½ x 9½ in (31.8 x 24 cm); pastel
The presence of the bar implies that Degas made
this pastel in a rehearsal room, but he preferred
dancers to model in his studio. This pose has not
been found in any of his paintings, and Degas'
signature indicates that it is a finished work.

LITTLE DANCER AGED 14
Edgar Degas; 1881;
39 x 16½ in (98.4 x 42 cm); bronze
The original wax sculpture from
which this bronze was cast shocked
and impressed critics at the sixth
Impressionist exhibition of 1881.
Degas had taken realism to its
extreme by dressing the figure
in a real tutu and a silk ribbon.

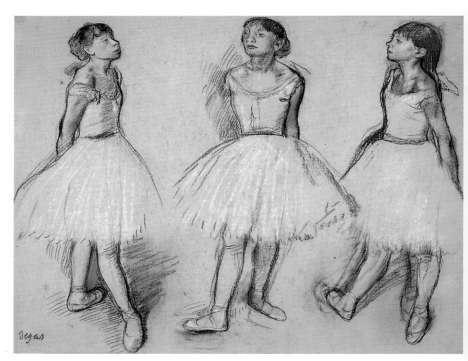

NUDE STUDY FOR THE DANCER
Edgar Degas; c.1878–79; 29 in (72.4 cm); bronze
Sketches (above) and this nude statuette
preceded the final sculpture. Degas'
use of real clothes rendered his
work "thoroughly modern."

THREE STUDIES OF A DANCER IN FOURTH POSITION
Edgar Degas; c.1879–80; 19 x 24 in (48 x 61.5 cm); pastel
Degas' little dancer has been identified as the
Belgian ballerina Marie van Goethan. For this
large-scale charcoal and pastel study, Degas
viewed his model in a fourth position pose from
three angles, in preparation for the final sculpture.

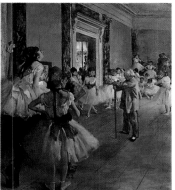

THE DANCE CLASS
Edgar Degas; c.1873–76;
33½ x 29½ in (85 x 75 cm)
Degas' composition
of a rehearsal with the
famed choreographer
Jules Perrot underwent
many revisions.

BALLET MASTER
Edgar Degas; 1874;
17¾ x 10¼ in (44.9 x
26.1 cm); crayon on paper
This may be a sketch for
a figure found beneath
Perrot in an X-ray of
the painting (left).

The Curtain
EDGAR DEGAS *c.1880; 10¾ x 12¾ in*
(27.3 x 32.4 cm); pastel over monotype
As the curtain hovers above the stage and a dancer
flits past him and out of the frame, a top-hatted "lion"
– as the men who roamed backstage at the Opéra
were known – surveys the scene with proprietorial
nonchalance. Half-hidden by scenery, two other
lions wait in the wings, attracted less by the ballet
than by the ballerinas. Affairs between the dancers
and powerful men were a fact of Parisian life. Rich
subscribers enjoyed privileges, including the right
to stand in the wings during a performance, as here.

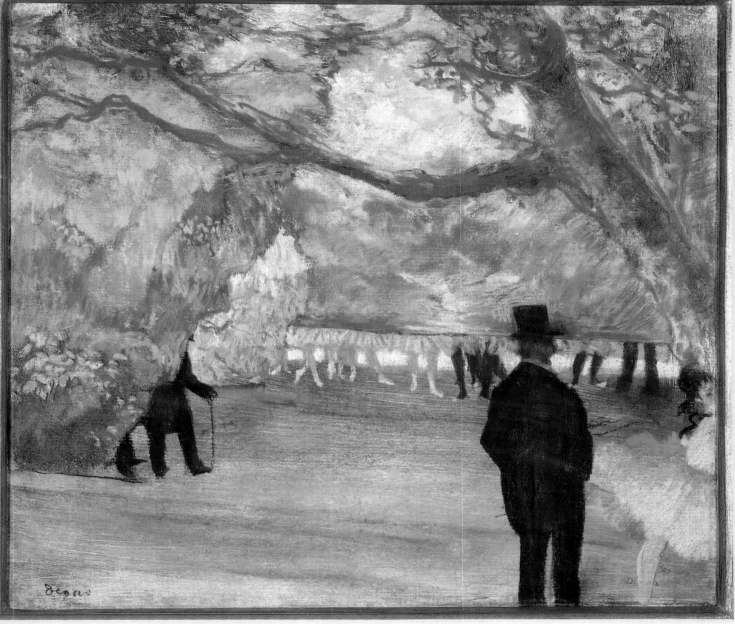

STAGE SCENERY
Degas' admiration for
the bold style of Japanese prints
(pp. 54–55) is evident in the way
the composition is dominated by
decorative scenery, cutting off his
figures and creating unusual views.

EMPTY CENTER
One of the striking elements of
the composition is the fact that the
central area, traditionally the focus
of interest, consists of the bare, empty
boards of the stage. The "action" is
pushed to the sides and background.

LEGS REVEALED
Compositional originality is
combined with a mocking sense of
humor. Just as the two lions emerge
from the wings in a ridiculously
incomplete silhouette, ballerinas'
legs seem to dangle from the curtain.

EXPRESSIVE BACK VIEW
Degas captured the essence of
a pose even from behind, as in the
main figure. He was drawn over the
dancer's trailing leg: the flash of her
red ribbon and her full white tutu
emphasize his sinister darkness.

Inspired by Japan

JAPANESE WOODBLOCK PRINTS were first seen in France in the 1850s and soon became immensely popular. Many of the Impressionists had collected these prints, known as *ukiyo-e* ("images of the floating world"), since the days of the Batignolles group (p. 16), when they were labeled the "Japanese of painting." The prints both inspired and confirmed the Impressionists' own ideas about color and form, revealing a very different approach to composition than that of the Western tradition. Japanese artists combined areas of solid color with stylized outlines, emphasizing the surface pattern of the print rather than the illusion of space beyond the picture plane (p. 63). While European artists created a sense of space and depth using perspective, Japanese printmakers implied spatial relationships by placing one object behind another in overlapping planes. In the absence of a single point of focus, the viewer's eye was encouraged to wander over the flat, decorative surface. The prints' striking designs often included unusual viewpoints and figures cut off by the edge of the picture, echoing the effects of snapshots (pp. 28–29) and inspiring many Impressionist compositions.

Embroidered Japanese kimono, similar to that worn by Camille Monet (left)

THE JAPANESE CRAZE
Japan had been closed to the West until the 1850s, when new trading agreements brought its artifacts into Europe. When *Le Porte Chinoise* shop opened in Paris in 1862, selling items such as fans, prints, and kimonos, it found eager customers among artists. Not only inspired by Japanese art, they also used Oriental objects as props in their work.

LA JAPONAISE
Claude Monet; 1876;
91¼ x 56 in (231.6 x 142.3 cm)
This contrived, even vulgar image of Camille, Monet's wife, dressed in a blonde wig and embroidered kimono, was a huge success at the second Impressionist show. Monet later described it as "trash." The real Japanese influence on his art was far more subtle.

ROCKS AT BO-NO-URA
Ando Hiroshige;
c.1853–56; woodblock print
One of the many Japanese prints in Monet's collection, this seascape by the 19th-century master Hiroshige, reveals the qualities of bold color and strong design that appealed to the Impressionists. The sky and sea are shown in a triple band of flat color, on which precisely outlined forms of rocks and boats have been positioned. The rectangles of the traditional signature boxes emphasize the sense of a two-dimensional surface pattern.

ROCKS AT BELLE-ILE
Claude Monet; 1886; 25½ x 31½ in (65 x 80 cm)
The subject matter of this painting, showing the Needle rocks in Brittany, has obvious links with Hiroshige's print (left). But it is Monet's way of depicting the scene that shows his assimilation of the formal language of Japanese art. Marrying naturalism with decoration, he evokes the choppy sea and barbed rocks with vigorous brushwork, at the same time creating a powerful pattern by setting the dark shapes of the rocks against a blue backdrop.

THE STRANGER AT THE GATE
Isoda Koryusai;
1771; pillar print
Narrow, elongated pillar prints (*hashirakake*) such as this were designed to decorate the wooden pillars of Japanese houses. The restraints imposed by the format represented a significant challenge to artists, and they often reveal Japanese art at its most elegantly stylized. Parasol in hand – like so many of the women in Impressionist art – the figure is squeezed into a thin band of space, her dark kimono set against the pale grid of a bamboo gateway behind her. The narrowness of the print accentuates the long line of the kimono and the unnaturalistic sense of space. The pillar format inspired Degas (right).

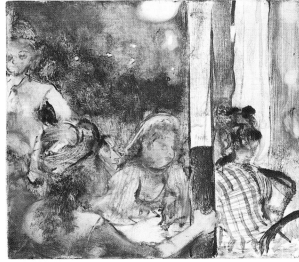

CAFE SCENE
Edgar Degas; c.1876; 10½ x 11¾ in
(27 x 29.8 cm); monotype
In Degas' monotype, as in his pastel (right) and Kiyonaga's print, an off-center pillar stretches from the top to the bottom of the image, stressing the picture's flat surface.

WOMEN ON A CAFE TERRACE
Edgar Degas; 1877; 16¼ x 23½ in
(41 x 60 cm); pastel over monotype
Somewhat less stylish than their Japanese counterparts, four Parisian prostitutes watch potential clients go by. One rises from her seat, perhaps to follow the disappearing male figure, who is cut off by the door frame to the right. She herself is cut in two by a pillar.

MARY CASSATT AT THE LOUVRE
Edgar Degas; 1885;
12 x 5½ in (31.3 x 13.7 cm); pastel over etching
The reference to Japanese pillar prints is clear in this superb picture of Mary Cassatt, who shared Degas' passion for Japanese art (pp. 56–57). Stylized and decorative, it echoes Japanese prints in a number of ways, besides its format: the high viewpoint; the overlapping of figures and their cropping off by the wall (that narrows the space even more); the uptilting of the floor; and the geometric background shapes, against which the figures are set. Even the way the line of Cassatt's suit is continued by the skirt of her companion evokes the long, sweeping curve of a kimono.

THREE WOMEN LOOK INTO A SNOW-COVERED GARDEN
Torii Kiyonaga; c.1786; woodblock print
Most *ukiyo-e* focused on the transient world of the theater and the daily life of prostitutes. Degas favored similar subject matter; in both content and form, his café scenes (below and left) echo Kiyonaga's image of courtesans.

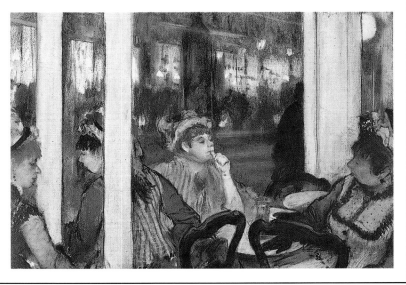

Cassatt's color prints

MARY CASSATT
(1844–1926)
The daughter of a wealthy American banker, Cassatt studied art in the U.S. and traveled in Europe before settling in Paris in 1874.

IN APRIL 1890, Mary Cassatt wrote excitedly to her friend and neighbor Berthe Morisot, inviting her to visit a huge exhibition of Japanese *ukiyo-e* prints (p. 54): "You must not miss it. You ... couldn't dream of anything more beautiful. I dream of it and don't think of anything but color on copper." Like many artists and writers in Paris, Cassatt was an enthusiastic collector of Japanese prints. And her interest in experimental printmaking had been fostered by Degas and Pissarro since 1879, when she became involved with their plans for a fine-art print journal. It never appeared, but Cassatt, Degas, and Pissarro showed their innovative prints at the fifth Impressionist exhibition of 1880. A decade later, inspired by the *ukiyo-e* exhibition she had seen, Cassatt set out to produce "a set of ten prints [in] imitation of Japanese methods," based on women's domestic routines. It took almost a year to complete; each image required several plates, one for line and one for each color. Like *ukiyo-e*, every print was unique. By April 1891, the completed 25 sets of ten prints were ready for exhibition and sale.

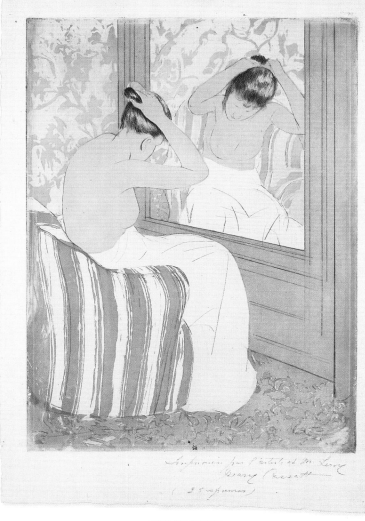

THE COIFFURE
Mary Cassatt; 1891; 17 x 11¾ in (43.3 x 29.9 cm); drypoint and aquatint
The image of a woman looking in a mirror, with her arms upstretched to arrange her hair, was well known in Japanese art. Here, Cassatt has created a French bourgeois equivalent. As in *ukiyo-e*, an elegant simplicity of line combines with areas of flat color, which vary in intensity for the chair, carpet, and wallpaper.

**DRAWING FOR
THE CHEVAL GLASS**
Berthe Morisot; 1890; 11¾ x 7¾ in (30 x 20 cm); pencil on paper
Cassatt and Morisot worked closely together around 1890, the year that Morisot made this drawing of a woman attending to her hair. A drawing by Cassatt showing an identical pose was probably made at the same time and became the basis of *The Coiffure* (left). In both drawings the woman sits on the right, but her position was reversed when Cassatt transferred the design to a copper etching plate. The choice of a semi-nude model, unusual for Cassatt, may have been influenced by Morisot.

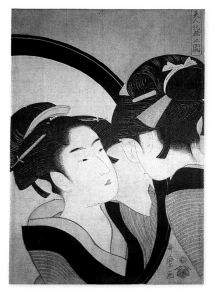

WOMAN WITH A MIRROR
Kitagawa Utamaro; late 18th century; woodblock print
Cassatt's own collection of *ukiyo-e* included works by masters from both the 18th and 19th centuries. Her work is often associated with that of Kitagawa Utamaro (1753–1806), the most popular artist of his day in Japan. His print series of serenely beautiful women, depicted in everyday activities, such as checking their hair, has obvious links with the series by Cassatt. As in Cassatt's prints, Utamaro shows a back view of the woman, exposing the nape of her neck – traditionally an area of beauty in Japan.

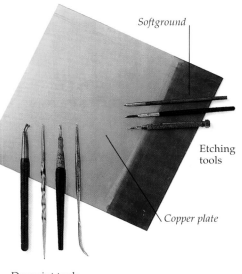

Softground

Etching tools

Copper plate

Drypoint tools

EXPOSITION
de
TABLEAUX, PASTELS
et
GRAVURES
PAR
M^{lle} Mary Cassatt

Galerie Durand-Ruel
Avril 1891

THE PRINTER LEROY
The printing process, in which several inked plates had to be precisely registered, required a great deal of technical expertise. Following Japanese tradition, Cassatt credited her printer on the final prints, writing "printed by the artist and M. Leroy" (below). This drypoint of Leroy printing at his press is by Marcellin Desboutin (p. 25), who introduced Cassatt to Leroy.

DURAND-RUEL'S SHOW
Cassatt's color prints formed the basis of her first solo show, held in Paris in April 1891. Durand-Ruel exhibited and marketed them – sending seven of the 25 sets to New York.

PRINTMAKING TOOLS
Cassatt mixed printer's inks for her colors and used a variety of techniques to create expressive lines and subtle textures: softground etching, drypoint, aquatint, and hand touches (p. 63).

The Lamp
MARY CASSATT *1891; 12¾ x 10 in (32.2 x 25.3 cm); drypoint, softground etching, and aquatint*
Framed decoratively by her furniture and a fan, a woman sits by a lampshade, with her back turned in an elegant pose. Despite the lamp, there are no shadows, just the uniform light that exists in *ukiyo-e*.

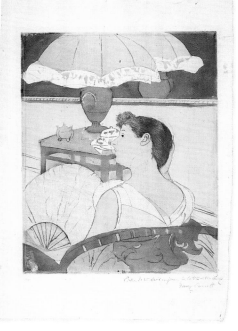

ANOTHER IMPRESSION: THE LAMP
Mary Cassatt; 1891; 17 x 11½ in (43.2 x 29.7 cm); drypoint, softground etching, and aquatint
This is also a final print of *The Lamp*. Both versions show a "deliberate mistake": overlapping the flesh-tone area with the dress, to reveal the artist's hand.

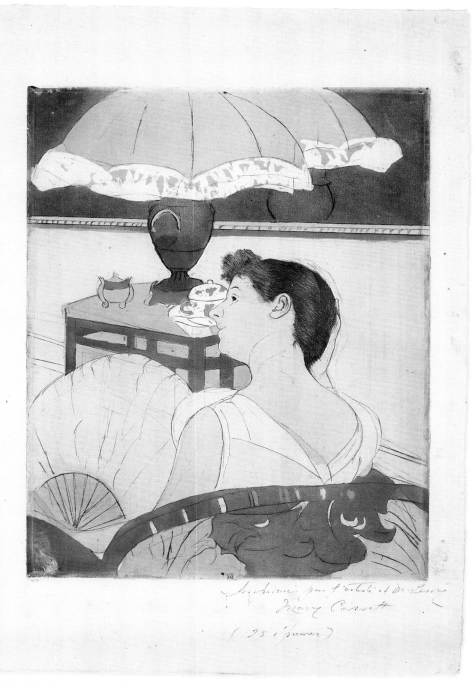

Impressionism in crisis

THE FINAL EXHIBITION OF 1886
The names of Monet, Sisley, Caillebotte, and Renoir are noticeably absent from this poster for the eighth, and final, exhibition of 1886. That year, the art critic Félix Fénéon declared that Impressionism was dead, succeeded by a new, scientific art, which he termed "Neo-Impressionism."

DURING THE 1870S, IMPRESSIONISM WAS AT ITS HEIGHT, and the group was at its most unified. By the 1880s, stylistic differences and personal squabbles had come to the fore. Problems focused on who should be allowed to show with the group, with the irascible Degas often at the center of disputes. Although he had always refused the label "Impressionist," he was committed to the idea of independent shows and was eager to include new artists. However, most of the others saw the work of Degas' protégés as compromising the aims of Impressionism. In 1880, Monet refused to join the group show, because "the little clique has become a great club." Only Pissarro showed at all eight exhibitions, and ironically it was the new, more theoretical art of his friends Georges Seurat and Paul Signac, shown in the 1886 exhibition, that marked the end of the original Impressionist movement.

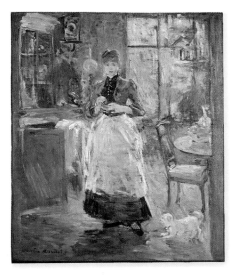

IN THE DINING ROOM
Berthe Morisot; 1885–86; 24 x 19¼ in (61.3 x 50 cm)
Morisot and her husband, Eugène Manet, acted as financial backers for the 1886 show and took an active role in selecting the artists. Morisot herself showed various works, including this painting of her maid in the dining room.

THE MORNING BATH
Edgar Degas; 1887–90; 26¼ x 17¼ in (66.8 x 45 cm); pastel
In the 1886 exhibition, Degas included 15 pastels, cataloged as a "suite of nude women, bathing, washing themselves ... dressing themselves, or being dressed." This pastel of a woman stepping into her tub shows his mastery of the medium.

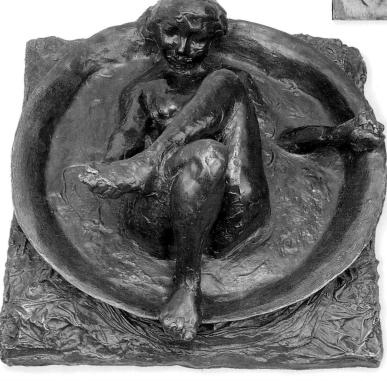

THE TUB
Edgar Degas; c.1886; 19¾ x 8½ in (50 x 21.6 cm); bronze
This sculpture, related to the 1886 pastel series (above), reveals the experimental, bold nature of Degas' art. First made in wax (this is a bronze cast), the base and water were created from rags and plaster. The relationship between illusion and reality was also heightened by the fact that the bather lay in an actual metal basin.

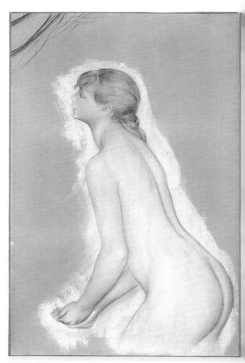

STUDY FOR THE BATHERS
Auguste Renoir; c.1884–85; 38¾ x 25¼ in (98.5 x 64 cm); colored chalk on paper
By the early 1880s, Renoir felt that he had "come to the end of Impressionism," and that he "didn't know how to paint or draw." Inspired partly by the linear grace of the classical and Renaissance art he had seen on a trip to Italy in 1881, he replaced his feathery brushstrokes with crisply outlined, carefully modulated forms, as in this study.

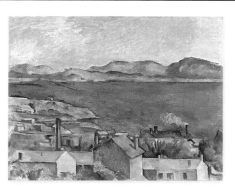

LETTER FROM PISSARRO
Pissarro tells his son of
the problems with the 1886
show, which focused on
Seurat's "progressive art."

THE BAY OF MARSEILLES
Paul Cézanne; 1886–90;
31½ x 39½ in (80.2 x 100.6 cm)
Achieving his aim to
make "something solid of
Impressionism," Cézanne
had a major influence
on 20th-century art.

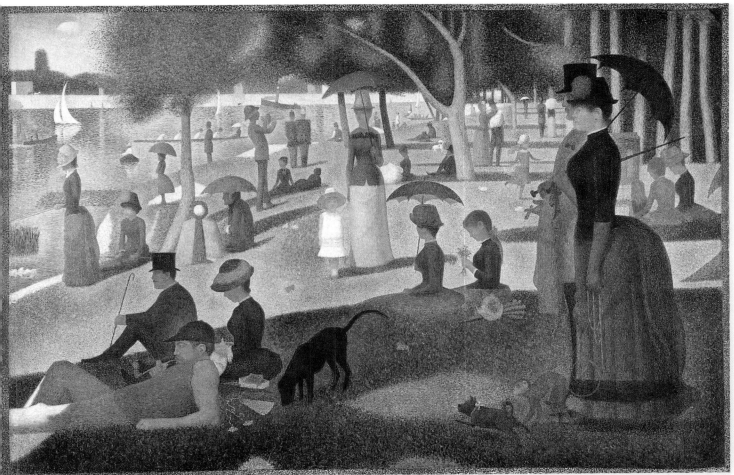

SUNDAY AFTERNOON ON THE ISLAND OF LA GRANDE JATTE
Georges Seurat; c.1884–86; 81¼ x 121¼ in (207.6 x 308 cm)
This huge painting was hung with other Neo-Impressionist
works in a separate room in the 1886 exhibition. Although its
subject matter has precedents in the works of Manet (pp. 8–9)
and the Impressionists, Seurat evolved a novel, stylized way
of presenting the modern world. Incorporating a systematic
application of scientific color theories, he has covered the
canvas in dots of pure color intended to gain in vibrancy
by partially mixing in the viewer's eye.

DIVISIONIST DOTS
Seurat based his art
on the color theories
of Chevreul (p. 20)
and others. This detail
from *La Grande Jatte*
(magnified seven
times) illustrates the
"divisionist" use of
even dots of color.

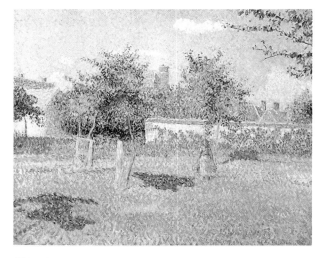

WOMAN IN A FIELD
Camille Pissarro; 1887;
21¼ x 25½ in (54 x 65 cm)
Although he was
always a father figure
in the Impressionist
movement, Pissarro
remained open to new
ideas from younger
artists. Between 1885
and 1890, he embraced
the aims and style of
Neo-Impressionism.
Politically attracted
to the impersonal,
"unromantic" nature
of Seurat's pointillist
(*point* means "dot"
in English) technique,
he also favored the use
of more brilliant color.

World Impressionism

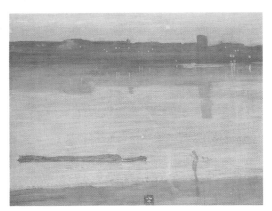

NOCTURNE IN BLUE-GREEN
James Abbott McNeill Whistler;
1871; 19¾ x 23¼ in (50.2 x 59.1 cm)
An American who trained in Paris and settled in London, Whistler was friendly with some of the Impressionists. He shared many of their concerns – with light and with Japanese art, as shown in this poetic evening view of the River Thames – but he pursued an individual course.

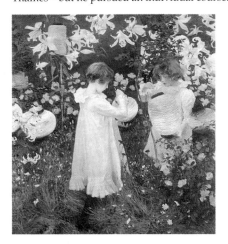

THE IMPRESSIONISTS OF PARIS were not alone in their approach to art. Around the world, artists began to choose modern-day subjects, painted outdoors, used bright colors, and sometimes even called themselves "Impressionists." In 1915, the critic Christian Brinton wrote that, though Paris was "the spot whence radiated this new gospel, there sprang up over the face of Europe, and also in America, countless ... apostles of light, who soon changed the complexion of modern painting from black and brown to blond, mauve, and violet." A debate has since developed as to what extent these "foreign" artists were influenced by the French, and how far French Impressionism is just one example of the modern spirit. Some groups, such as the Italian Macchiaioli, developed a similar way of painting independently, but others were clearly inspired by seeing Impressionist works on display, or by studying in Paris.

CARNATION, LILY, LILY, ROSE
John Singer Sargent; 1885–86; 68½ x 60½ in (174 x 153.7 cm)
Like Whistler, Sargent was an American who trained in Paris, knew the Impressionists, and worked in England – where he painted this exquisitely luminous picture, which is closely linked to Impressionist principles. In order to capture the particular twilight effect, Sargent worked outdoors in ten-minute bursts, over two autumns.

SCENE AT GIVERNY
Theodore Robinson; 1890;
16 x 25¾ in (40.6 x 65.4 cm)
Though Sargent and Cassatt spread the word of Impressionism in the United States, it was Durand-Ruel's 1886 exhibition, "Impressionist of Paris" (p. 43), that marked the beginning of American awareness. Theodore Robinson left America to paint in France in 1887, returning five years later. He visited Monet at Giverny (p. 38) and painted this boldly colored picture at around the time that Monet was working on his magnificent *Haystacks* series.

CHILDREN PADDLING, WALBERSWICK
Philip Wilson Steer; 1889–94; 25¼ x 36½ in (64.2 x 92.4 cm)
One of the self-styled "London Impressionists" who
exhibited in a group show in 1889, Steer rejected the
Victorian conventions of the Royal Academy in London
in favor of the Impressionists' freely handled paint,
vibrant color, and modern-day subjects. This Suffolk
beach scene typifies his decorative style.

BLUE INTERIOR
Harriet Backer; 1883;
33 x 26 in (84 x 66 cm)
Harriet Backer, a Norwegian
painter, worked in Paris for ten
years. She was inspired by the
Impressionist approach to color
and light, and called scenes
such as this "*plein-air*
interiors."

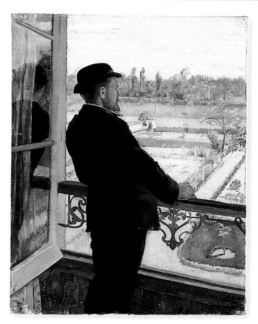

**PORTRAIT OF THE SWEDISH
PAINTER KARL NORDSTROM**
Christian Krohg; 1882; 24¼ x 18¼ in (61.6 x 46.4 cm)
The Norwegian painter Krohg depicted his
Swedish friend near Fontainebleau, in a pose
similar to Caillebotte's *The Man at the Window*
(p. 6). Like many Swedish artists, Nordström
sought motifs in Paris in the 1880s.

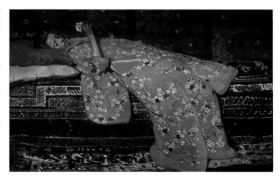

GIRL IN A RED KIMONO
George Hendrik Breitner;
c.1893; 19¾ x 27½ in (50.5 x 70 cm)
Breitner was a student in
Paris in 1884; when he
returned to Holland,
he became the leading
exponent of Dutch
Impressionism. His
street scenes echo
Caillebotte's; here,
he is influenced
by Whistler's
"Japanese" style.

**MR. KUME
IN HIS ATELIER**
Seiki Kuroda; 1889;
15½ x 18¾ in (39.5 x 47.7 cm)
Japanese artists in Paris
found obvious affinities with
Impressionism, since it had
been influenced by Japanese
art. Here, Kuroda creates
an Impressionist sense of
immediacy in his brush-
work and light effects.

THE SELECTOR'S HUT
Arthur Streeton; 1890;
30¼ x 20 in (77 x 51 cm)
Streeton and the other Australian
Impressionists were dedicated to
open-air painting and capturing
"very fleeting effects." As in
this painting, a dazzling golden
light bathes their landscapes.

Key biographical dates

CAMILLE PISSARRO
1830 Jacob Abraham Camille Pissarro born on St. Thomas in the West Indies, July 10.
1842–47 Sent to school in Paris.
1855 Spends time at the Ecole des Beaux-Arts and begins to attend classes at the Académie Suisse.
1870 Franco-Prussian War – goes to London. Almost all his works destroyed by Prussians.
1872–84 Settles at Pontoise; visited by Cézanne and Gauguin.
1880s Adopts pointillist technique of Seurat and Signac.
1884 Settles at Eragny-sur-Epte.
1903 Dies in Paris, November 13.

EDOUARD MANET
1832 Born in Paris, January 25.
1850–56 Pupil in Thomas Couture's studio. Studies old masters at the Louvre.
1863 Exhibits *Déjeuner sur l'Herbe* at the Salon des Refusés.
1865 *Olympia* a scandal at the Salon.
1867 One-man show at World's Fair.
1870 Franco-Prussian War – joins National Guard.
1874 Paints with Monet in Argenteuil.
1883 Leg amputated. Dies, April 30.

EDGAR DEGAS
1834 Hilaire-Germain-Edgar de Gas born in Paris, July 19.

1855 Abandons law studies; enters Ecole des Beaux-Arts.
1856–61 Travels and studies in Italy.
1870 Franco-Prussian War – joins National Guard.
1877 Invites Cassatt to exhibit with the Impressionists.
1880s Eyesight begins to fail, leaving him almost blind for the last 20 years of his life.
1890s Models numerous wax sculptures of women and horses.
1917 Dies in Paris, December 27.

ALFRED SISLEY
1839 Alfred Sisley born in Paris, October 30, to English parents.
1857–59 Business career in London.
1860 Returns to Paris; enters Gleyre's studio; meets Bazille, Monet, and Renoir.
1870 Sisley's possessions destroyed in war. Father suffers financial ruin; Sisley lives in poverty until his death.
1875–78 Lives in Marly-le-Roi.
1889 Finally settles in Moret.
1899 Dies of throat cancer, January 29.

CLAUDE MONET
1840 Oscar-Claude Monet born in Paris, November 14.
1859 Enters Académie Suisse; meets Pissarro.
1862–64 In Gleyre's studio; meets Renoir, Sisley, and Bazille; leads

open-air painting trips to forest of Fontainebleau.
1870 In London during Franco-Prussian War; meets Durand-Ruel.
1871–78 Lives in Argenteuil.
1883 Settles in Giverny.
1914–26 Works on huge waterlily "decorations" based on his garden, despite increasing blindness.
1926 Dies at Giverny, December 5.

BERTHE MORISOT
1841 Born in Bourges, January 14.
1858 Copies old masters in the Louvre.
1860s Influenced by Corot.
c.1867 Meets Edouard Manet.
1874 Marries Eugène Manet, the artist's brother.
1878 Only child, Julie, born.
1895 Dies in Paris, March 2.

AUGUSTE RENOIR
1841 Pierre-Auguste Renoir born in Limoges, February 25.
1856 Trains as a porcelain painter.
1862–64 In Gleyre's studio. Studies old masters at the Louvre and begins to paint outdoors.
1879 *Madame Charpentier and Her Children* a huge success at the Salon.
1882–83 Travels extensively; adopts new "harsh" style for several years.
1890s Begins to suffer from arthritic condition.
1907 Settles in Cagnes, in the South of France.

1919 Dies in Cagnes, December 3.

MARY CASSATT
1844 Born in Pittsburgh, Pa., May 22.
1865–70 Travels in Europe.
1874 Settles in Paris.
1879 First exhibits with the Impressionists, at Degas' invitation.
1891 Solo show, at Durand-Ruel's.
1926 Dies at Beaufresne, June 14.

GUSTAVE CAILLEBOTTE
1848 Born in Paris, August 19.
1870 Serves in Garde Mobile.
1874 Inherits vast fortune.
1876 Gives financial support to others in the group; makes a will bequeathing his collection of Impressionist works to France.
1880s Settles at Petit-Gennevilliers, near Argenteuil.
1894 Dies at Petit-Gennevilliers, March 2.

Impressionist paintings in 1905 at the Grafton Galleries exhibition in London

The Impressionist exhibitions, 1874–1886

ARTISTS	1874	1876	1877	1879	1880	1881	1882	1886
Astruc, Zacharie	X							
Attendu, Antoine	X							
Béliard, Edouard	X	X						
Boudin, Eugène	X							
Bracquemond, Félix	X			X	X			
Bracquemond, Marie				X	X			X
Brandon, Edouard	X							
Bureau, Pierre	X	X						
Caillebotte, Gustave		X	X	X	X		X	
Cals, Adolphe-Félix	X	X	X	X				
Cassatt, Mary				X	X	X		X
Cézanne, Paul	X		X					
Colin, Gustave	X							
Cordey, Frédéric			X					
Debras, Louis	X	X						
Degas, Edgar	X	X	X	X	X	X		X
Desboutin, Marcellin		X						
Forain, Jean-Louis				X	X	X		X
François, Jacques			X					
Gauguin, Paul				X	X	X	X	X
Guillaumin, Armand	X		X	X	X	X	X	X
Lamy, Franc			X					
Latouche, Louis	X							
Lebourg, Albert				X	X			
Legros, Alphonse		X						
Lepic, Ludovic-Napoleon	X	X						
Lépine, Stanislas	X							
Levert, Léopold	X	X	X		X			
Maureau, Alphonse			X					
Meyer, Alfred	X	X						
Millet, Jean-François		X						
Molins, Auguste de	X							
Monet, Claude	X	X	X	X			X	
Morisot, Berthe	X	X	X		X	X	X	X
Mulot-Durivage, Emilien	X							
Nittis, Guiseppe de	X							
Ottin, Auguste	X	X						
Ottin, Léon	X	X						
Piette, Ludovic			X					
Pissarro, Camille	X	X	X	X	X	X	X	X
Pissarro, Lucien								X
Raffaelli, Jean-François					X	X		
Redon, Odilon								X
Renoir, Auguste	X	X	X				X	
Robert, Léopold	X	X						
Rouart, Henri	X	X	X	X	X			X
Schuffenecker, Emile								X
Seurat, Georges								X
Signac, Paul								X
Sisley, Alfred	X	X	X				X	
Somm, Henri				X				
Tillot, Charles		X	X	X	X	X	X	X
Vidal, Eugène						X		
Vignon, Victor					X	X	X	X
Zandomeneghi, Federico				X	X	X		X

Paintings on exhibit

The following is a list of the galleries and museums that exhibit the paintings that are reproduced in this book. Unless otherwise stated, all paintings are oil on canvas.

Key: t = top b = bottom c = center l = left r = right

p. 7 tl: *The Millinery Shop*, Degas, Art Institute of Chicago; b: *Bathers at La Grenouillère*, Monet, National Gallery, London.

pp. 8–9 *Music in the Tuileries Gardens*, Manet, National Gallery, London.

p. 10 tl: *Lost Illusions*, Gleyre, Musée d'Orsay, Paris; cl: *Alfred Sisley*, Renoir, Art Institute of Chicago; r: *Claude Monet*, Carolus-Duran, Musée Marmottan, Paris; b: *Auguste Renoir*, Bazille, Musée des Beaux-Arts, Algiers; bc: *Frédéric Bazille*, Renoir, Musée d'Orsay, Paris.

p. 11 tl: *Self-Portrait*, Pissarro, Musée d'Orsay, Paris.

p. 12 b: *Landscape at Chailly*, Bazille, Art Institute of Chicago.

p. 13 tr: *View of Genoa*, Corot, Art Institute of Chicago; cl: *Entrance of the Port of Honfleur*, Jongkind, Art Institute of Chicago; br: *The Beach at Sainte-Adresse*, Monet, Art Institute of Chicago.

pp. 14–15 *On the Seine at Bennecourt*, Monet, Art Institute of Chicago.

p. 16 bl: *Emile Zola*, Manet, Musée d'Orsay, Paris; br: *A Studio in the Batignolles Quarter*, Fantin-Latour, Musée d'Orsay, Paris.

p. 17 tr: *Self-Portrait*, Bazille, Art Institute of Chicago.

p. 18 c: *The Salon Jury*, Gervex, Musée d'Orsay, Paris; bl: *Olympia*, Manet, Musée d'Orsay, Paris.

p. 19 tr: *Impression, Sunrise*, Monet, Musée Marmottan, Paris; bl: *The Cradle*, Morisot, Musée d'Orsay, Paris.

p 20 br: *Self-Portrait*, Delacroix, Louvre, Paris.

p. 21 c: *Regatta at Argenteuil*, Claude Monet, Musée d'Orsay, Paris.

pp. 22–23 *Two Sisters*, Renoir, Art Institute of Chicago.

p. 24 tr: *Café Singer*, Degas, Art Institute of Chicago; bl: *The Waitress*, Manet, National Gallery, London.

p. 25 tr: *The Reader*, Manet, Art Institute of Chicago; l: *L'Absinthe*, Degas, Musée d'Orsay, Paris.

p. 26 bl: *A Corner in the Moulin de la Galette*, Toulouse-Lautrec, Art Institute of Chicago.

pp. 26–27 *The Dance at the Moulin de la Galette*, Renoir, Musée d'Orsay, Paris.

p. 29 tl: *Boulevard des Capucines*, Monet, Nelson-Atkins Museum, Kansas City; b: *The Place Clichy*, Renoir, Fitzwilliam Museum of Art, Cambridge, UK.

p. 30 bl: *Rue Montorgeuil, Paris*, Monet, Musée d'Orsay, Paris.

pp. 30–31 *Paris, a Rainy Day*, Caillebotte, Art Institute of Chicago.

p. 32 b: *Le Pont de l'Europe, Gare Sainte-Lazare*, Monet, Musée Marmottan, Paris.

p. 33 tl: *Le Pont de l'Europe*, Caillebotte, Musée de Petit Palais, Geneva; cr: *Lordship Lane Station, Dulwich*, Pissarro, Courtauld Institute Galleries, London; br: *Train in the Countryside*, Monet, Musée d'Orsay, Paris.

p. 34 b: *The Rower's Lunch*, Renoir, Art Institute of Chicago.

p. 35 tl: *The Bridge at Argenteuil*, Monet, Musée d'Orsay, Paris; tr: *Autumn, Banks of the Seine*, Sisley, Montreal Museum of Fine Arts; c: *Summer's Day*, Morisot, National Gallery, London; bc: *Auvers , Panoramic View*, Cézanne, Art Institute of Chicago; br: *The Climbing Path, l'Hermitage*, Pissarro, Brooklyn Museum, New York.

p. 36 cl: *Saint-Martin Canal*, Sisley, Musée d'Orsay, Paris.

pp. 36–37 *The Seine at Port-Marly: Piles of Sand*, Sisley, Art Institute of Chicago.

p. 38 b: *Monet's House at Argenteuil*, Monet, Art Institute of Chicago.

p. 39 tl: *Monet Painting in His Garden at Argenteuil*, Renoir, Wadsworth Atheneum, Hartford, Conn.; c: *The Monet Family in Their Garden*, Manet, Metropolitan Museum of Art, New York; bl: *The Butterfly Chase*, Morisot, Musée d'Orsay, Paris.

p. 40 t: *The Gleaners*, Millet, Musée d'Orsay, Paris; l: *Woman and Child at the Well*, Pissarro, Art Institute of Chicago.

p. 42 cr: *Madame Charpentier and Her Children*, Renoir, Metropolitan Museum of Art, New York.

p. 44 b: *Five o'Clock Tea*, Cassatt, Museum of Fine Arts, Boston.

p. 45 bl: *Fruits from the Midi*, Renoir, Art Institute of Chicago; br: *The Plate of Apples*, Cézanne, Art Institute of Chicago.

pp. 46–47 *Lady at Her Toilette*, Morisot, Art Institute of Chicago.

p. 48 l: *Jockeys in Front of the Stands*, Degas, Musée d'Orsay, Paris.

pp. 48–49 *The Races at Longchamp*, Manet, Art Institute of Chicago.

p. 50 bl: *La Loge*, Renoir, Courtauld Institute Galleries; br: *Bouquet in a Theater Box*, Renoir, Musée de l'Orangerie, Paris.

p. 51 tr: *Two Young Women in a Loge*, Cassatt, National Gallery of Art, Washington; bl: *Woman in a Loge*, Cassatt, Philadelphia Museum of Art.

p. 53 tl: *The Dance Class*, Degas, Musée d'Orsay, Paris.

p. 54 cl: *La Japonaise*, Monet, Museum of Fine Arts, Boston; br: *The Rocks at Belle-Ile*, Monet, Pushkin Museum, Moscow.

p. 58 cl: *In the Dining Room*, Morisot, National Gallery of Art, Washington.

p. 59 tr: *The Bay of Marseilles*, Cézanne, Art Institute of Chicago; c: *Sunday Afternoon on the Island of La Grande Jatte*, Seurat, Art Institute of Chicago; br: *Woman in a Field*, Pissarro, Musée d'Orsay, Paris.

p. 60 tl: *Nocturne in Blue-Green*, Whistler, Tate Gallery, London; cl: *Carnation, Lily, Lily, Rose*, Sargent, Tate Gallery, London; b: *Scene at Giverny*, Robinson, Detroit Institute of Arts.

p. 61 tl: *Children Paddling, Walberswick*, Steer, Fitzwilliam Museum, Cambridge, UK; tc: *Blue Interior*, Backer, National Gallery, Oslo; tr: *Portrait of the Swedish Painter Karl Nordström*, Krohg, National Gallery, Oslo; cr: *Girl in a Red Kimono*, Breitner, Stedelijk Museum, Amsterdam; br: *Mr. Kume in His Atelier*, Kuroda, Kume Museum, Tokyo; bl: *The Selector's Hut*, Streeton, Australian National Gallery, Canberra.

Glossary

Academic art Art that conformed to the standards of the French Academy, the official body that promoted traditional art based on classical ideals.

Aquatint A method of printmaking in which tonal areas rather than lines are created. A fine, acid-resistant powder is used to produce a grainy effect.

Broken color Paint applied in mosaiclike patches, or dragged across the canvas, so that it covers it irregularly.

Broken color

Complementary colors Two colors are "complementary" if they combine to complete the spectrum. The basic complementary pairs are red and green, blue and orange, and yellow and violet.

Cool colors The more blue in a color, the "cooler" it is said to be. Cool colors appear to recede; warm colors, containing larger amounts of red, appear to advance.

Drypoint A method of printmaking in which the image is scratched directly into the metal plate with a hard steel tool. The characteristic of drypoint is the raised "burr" left on either side of the cut line, which gives the print a soft, rich quality.

Earth colors Red and yellow browns, such as ochres, siennas, and umbers, which are naturally occurring iron-oxide pigments.

Etching A form of printmaking in which a design is cut into a metal plate with acid, then inked and printed.

Flat color Solid, unvaried color.

Gouache Opaque watercolor paint.

Ground The layer or layers of primer applied to a canvas to prepare it for painting.

Hatching Closely spaced, parallel lines to suggest shading. If sets of lines are crossed, the term "cross-hatching" is used.

Impasto Paint applied in thick, raised strokes.

Lithograph A print produced by a method of printing based on the antipathy of grease and water. An image is drawn in lithographic ink or greasy crayon onto a stone block (now often a zinc plate). The stone is wetted, rolled with ink, and passed through a printing press.

Monotype A single (mono) print made after painting directly onto a metal plate with oil paint or ink.

Neo-Impressionism A term coined by Félix Fénéon for the pointillist style of painting used by Seurat, Signac, and briefly, Pissarro.

Palette The flat surface on which an artist sets out and mixes paints. Also the range of colors used.

Picture plane The plane in the imaginary space of a picture that is occupied by the actual surface of canvas or paper.

Plein-air **painting** Painting outdoors.

Pointillism The Neo-Impressionist technique in which paint was applied in dots of pure color, designed to mix partially in the eye, and so gain in vibrancy. Both Seurat and Signac preferred to use the term "divisionism."

Priming See **Ground**.

Print An image made from an inked impression, which can be taken from a variety of worked surfaces, such as wooden block, metal plate, and stone. In relief methods (including Japanese *ukiyo-e*), the elements to be printed are left in relief, and the rest cut away. In *intaglio* methods, the image is cut into a metal plate with a tool and/or bitten into the plate with acid; these include line engraving, drypoint, etching, softground etching, and aquatint. Lithography is a surface method.

Pointillist technique

Salon France's annual official art exhibition, established in 1667.

Softground etching A form of etching characterized by its soft lines and grainy texture. The plate is coated with soft, sticky ground; a sheet of paper is laid over the plate, and the design drawn onto the paper in pencil – the pressure of which removes the soft ground. The plate is bathed in acid and printed as usual.

Warm colors (See **Cool colors**).

Wet-in-wet The application of one color of paint into or next to another, before the first is dry.

Index

A B

Acknowledgments

PICTURE CREDITS

Every effort has been made to trace the copyright holders and we apologize in advance for any unintentional omissions. We would be pleased to insert the appropriate acknowledgment in any subsequent edition of this publication.

Key: *t*: top *b*: bottom *c*: center *l*: left *r*: right

Abbreviations:
AIC: © Art Institute of Chicago, All Rights Reserved; **AM**: © Ashmolean Museum, Oxford; **ATP**: Musée des Arts et Traditions Populaires, Paris; **BAL**: Bridgeman Art Library, London; **BHVP**: Bibliothèque Historique de la Ville de Paris; **BN**: Bibliothèque Nationale, Paris; **DR**: Document Archives Durand-Ruel, Paris; **JLC**: Jean-Loup Charmet, Paris; **MM**: Musée Marmottan, Paris; **MO**: Musée d'Orsay, Paris; **NG**: Reproduced by courtesy of the Trustees, The National Gallery, London; **NGW**: © National Gallery of Art, Washington; **PC**: Private Collection; **PM**: David A. Loggie, The Pierpont Morgan Library, New York; **PVP**: Phototthèque des Musées de la Ville de Paris; **RMN**: Réunion des Musées Nationaux, Paris; **UFAC**: Union Française des Arts du Costume, Paris; **VL**: Visual Arts Library, London; **W&N**: Winsor & Newton, UK

p1: *c*: MO **p2**: *tl*: Ministère de la Defense, Etat Majeur de l'Armée de Terre, Service Historique de l'Armée de Terre; *tr*: MO; *cl*: Charles H. and Mary F. S. Worcester Collection, AIC; *cr*: Wirt D. Walker Fund, photo: Robert Hashimoto, AIC; *crt*: thanks to Chat Degote, Paris; *c*: Collection Medici; *bl*: br: MO **p3**: *tl*: BN; *c*: The Stickney Fund © AIC; *tr*: Museum of Bradford; *cr*: © Société Française de Photographie; *bl*: Gaylord Donnelley Restricted Gift, Print and Drawing Club Fund, AIC; *bc*: UFAC; *br*: AM **p4**: *tl*: thanks to Melvyn Petersen, Artichoke Prints; *tc*: Potter Palmer Collection, AIC; *tr*: Gift of Kate L. Brewster Estate, AIC; *cr*: PVP © DACS 1993; *bc*: Musée de l'Orangerie, Paris **p5**: *br*: MO **p6**: *c*: BN; *bl*: BHVP; *bc*: Musée Carnavalet/JLC; *br*: BHVP **p7**: *tl*: Mr. and Mrs. Lewis Larned Coburn Memorial Collection, AIC; *tr*: BN; *c*: Musée de la Publicité, Paris, all rights reserved; *br*: NG **p8**: *c*: Charles F. Glore Collection, AIC; *cl*: Charles Buckingham Collection, AIC; *bl*: PVP © DACS 1993 **pp8–9**: *c*: NG **p9**: *tc*, *cr*: UFAC **p10**: *tl*: MO/© Photo: RMN; *cr*: Mr. and Mrs. Lewis Larned Coburn Memorial Collection, AIC; *bc*: Musée des Beaux Arts, Algiers/BAL; *cr*: MM; *bl*: MO/VL **p11**: *tl*: MO/VL; *bl*: AM; *cr*: Helen Regenstein Collection, AIC; *bc*: British Library, London; *tr*: Joseph Brooks Fair Collection, AIC; *br*: AM **p12**: *tl*: Lefranc & Bourgeois, Le Mans; *bl*: Charles H. and Mary F.

S. Worcester Collection, AIC; *tr*: MO/RMN; *cr*: Sceaux, Musée de l'Ile de France/Lauros-Giraudon **p13**: *tl*: BN; *cl*: Louise B. and Frank H. Woods Purchase Fund (in honor of the Art Institute of Chicago's Diamond Jubilee), AIC; *bl*: The George A. Lucas Collection of the Maryland Institute, College of Art, on indefinite loan to The Baltimore Museum of Art; *tr*: Mr. and Mrs. Lewis Larned Coburn Memorial Collection, AIC; *cr*: W&N; *br*: Mr. and Mrs. Lewis Larned Coburn Memorial Collection, AIC **p14**: *tl*: BN; *cl*: Courtesy of The Fogg Art Museum, Harvard University Art Museums, bequest of Meta and Paul J. Sachs; *bl*, *br*: MO; *br*: PM **p17**: *tl*: Ministère de la Defense Etat Majeur de l'Armée de Terre, Service Historique de l'Armée de Terre; *cl*: AIC; *b*: Thanks to Henri Vuillemin; *tr*: Restricted Gift of Mr. and Mrs. Frank H. Woods in memory of Mrs. Edwards Harris Brewer, AIC; *c*: PVP © DACS 1993; *tr*: thanks to Patrice Reboul *DR*; *cr*: AM; *br*: Gift of Kate L. Brewster, AIC; *bl*: Mr. and Mrs. Martin A. Ryerson Collection, AIC **p46**: *c*: JLC **pp46–47**: The Stickney Fund, AIC **p48**: *tl*: BN; *cl*: MO; *tr*: thanks to Russell Harris **p49**: Potter Palmer Collection, AIC; *tl*: Gift of Robert Allerton, AIC; *tc*: Mr. and Mrs. Lewis Larned Coburn Memorial Collection, AIC; *tr*: MO/RMN **p50**: *tl*: UFAC; *cl*: thanks to Patrick Adam; *cr*: thanks to Gige; *bl*: Courtauld Institute Galleries, London; *br*: Musée de l'Orangerie, Paris **p51**: Gaylord Donnelley Restricted Gift, Print and Drawing Club Fund, AIC; *bl*: Philadelphia Museum of Art, bequest of Charlotte Dorrance Wright; *tr*: Chester Dale Collection, NGW; *br*: Gift of Mary and Leigh B. Block, AIC **p52**: *tl*: BN; *tr*: Mr. and Mrs. Martin A. Ryerson Collection, AIC; *bl*: Tate Gallery, London; *bc*: MO/RMN; *br*: Bequest of Adele R. Levy, AIC **p53**: *tl*: MO; *tc*: Gift of Robert Sonnenschein, AIC; *b*: Collection of Mr. and Mrs. Paul Mellon, Upperville, Virginia **p54**: *tl*: Museum of Fine Arts, Boston/Giraudon/BAL; *bc*: Monet's House and Garden at Giverny; *br*: Gift of Gaylord Donnelley in memory of Frances Gaylord Smith, AIC; *br*: Pushkin Museum, Moscow/BAL **p55**: *tl*: Clarence Buckingham Collection, AIC; *tc*: Gift of Kate L. Brewster Estate, AIC; *c*: Through prior bequest of the Mr. and Mrs. Martin A. Ryerson Collection, AIC; *cr*: Staatliche Museen zu Berlin – Preussischer Kulturbesitz Museum für Ostasiatische Kunst; *br*: MO **p56**: *tl*: Courtesy of the Pennsylvania Academy of Fine Arts, Philadelphia, Archives; *bl*: Mr. and Mrs. Potter Palmer Collection, AIC; *c*: Louvre/RMN; *br*: British Library, London/BAL **p57**: *tl*: Melvyn Petersen, Artichoke Prints; *tc*: BN; *tr*: DR; *bl*: Potter Palmer Collection, AIC; *br*: Mr. and Mrs. Martin A. Ryerson Collection, AIC; *bc*: Chester Dale Collection, NGW; *br*: Wirt D. Walker Fund, photo by Robert Hashimoto, AIC; *c*: Potter Palmer Collection, AIC;

br: Bequest of Kate L. Brewster, AIC **p59**: *tl*: AM; *tr*: Mr. and Mrs. Martin A. Ryerson Collection, AIC; *bl*: AIC; *br*: MO **p60**: *tl*, *cl*: Tate Gallery, London; *b*: © Detroit Institute of Arts, gift of Mrs. Christian H. Hecker **pp60–61**: *c*: artwork: Sallie Alane Reason **p61**: *tl*: courtesy of the Wilson Steer Estate/Fitzwilliam Museum, Cambridge; *bl*: Australian National Gallery, Canberra; *tc*: Photo: Jacques Lathion, Nasjonalgalleriet, Oslo; *cr*: Stedelijk Museum, Amsterdam; *br*: Kume Museum, Tokyo **p62**: *tr*: DR **p63**: *l*, *r* (details): AIC **Front cover**: *tl*: AIC; *cr*: Mme. Renée; *crb*: AIC; *br*: AIC; *bc*: AM; *bl*: Courtauld Institute Galleries, London; *clb*: thanks to Gige; *cl*: AIC; *clt*: BN; *c*: MM **Back cover**: *tl*: BN; *tr*: AIC; *crt*: MO; *br*: thanks to Russell Harris; *bc*: ATP/© RMN; *bl*: AIC; *clt*: AIC; *c*: *Two Sisters*, Renoir, AIC (also *cl*, *cr* details) **Inside front flap**: *t*, *b*: AIC

Additional Photography: Alison Harris: **p2**: *tl*, *ct*, *cb*; **p9**: *br*; **p17**: *tl*, *b*, *cr*; **p24**: *bc*; **p25**: *cr*, *br*; **p30**: *cl*, *tc*, *bc*; **p32**: *tl*; **p33**: *tr*; **p50**: *cl* Philippe Sebert: **p1**: *p2*: *tr*, *bl*, *br*; **p5**: *br*; **p6**: *br*; **p16**: *bl*, *br*; **p18**: *c*, *bl*; **p19**: *bl*; **p24**: *br*; **p25**: *cl*, *bl*, *br*; **pp26–27**: *c*; **p30**: *bl*; **p33**: *bl*; **p36**: *cl*; **p39**: *bl*; **p45**: *tl*; **p48**: *cl*; **p53**: *tl*; **p59**: *br*; **front cover**: *tl*; **back cover**: *cr* Phillip Gatward: **p20**: *tr* Susanna Price: **p4**: *br*; **p13**: *cr*, *bc*; **p14**: *tr*, *cr*; **p22**: *cl*; **p30**: *br*; **p32**: *bl*; **p34**: *cl*, *cr*; **p38**: *tl*, *cl*; **p50**: *br*; Alex Saunderson: **p19**: *tr*

Dorling Kindersley would like to thank:

Robert Sharp, Gloria Groom, John Smith, Inge Fiedler, and Elisabeth Dunn at the Art Institute of Chicago for all of their assistance. Also, the DK studio; Alison Harris for additional research in Paris; J. Patrice Marandel at the Detroit Institute of Art; Joseph Baillio of Wildenstein & Co., New York; the Service de Documentation at the Musée d'Orsay, Paris; and the Ashmolean Museum, Oxford, for allowing access to the Pissarro Archives. Thanks also to Mark Johnson Davies for design assistance, and Jo Evans for picture credits.

Author's acknowledgments:

I'm very grateful to the staff at the Art Institute of Chicago who made my research there so enjoyable and productive – in particular Robert Sharp, Associate Director of Publications, and Gloria Groom, Curator of European Paintings. Many thanks to my friends Amy Ambrose and Koyo Konishi for their kindness during my stay in Chicago. I'm grateful, as always, to Ian Chilvers for the extended loans from his library. Thanks also to Andy Welton for advice on horseracing; to Jane Gifford and Ann-Marie Le Quesne for their comments on printmaking techniques; and to David Edgar for his support and encouragement. The *Eyewitness Art* team deserve a special mention, particularly Luisa Caruso and Liz Sephton, with whom I've worked most closely. Finally, I'd like to say thanks to my parents, Aud and John Welton. I dedicate this book to them, with love.